686.22 BEA.

M 6 DEC 1997

HEREWARD CONFESCENT BRANSTON CRESCENT CONFINITION

7176

	•
and the state of t	

TYPE & COLOUR

MICHAEL BEAUMONT

MICHAEL BEAUMONT

TYPE & COLOUR

Published by Phaidon Press Limited 140 Kensington Church Street London W8 4BN OX1 1SQ

First published 1987 Copyright © 1987 Quarto Publishing plc

Reprinted 1991

British Library Cataloguing in Publication Data Beaumont, Michael

Type and colour. – (Graphic designer's library).

1. Type and type-founding

I. Title II. Series

686.2'2 Z250

ISBN 0-7148-2489-5

All rights reserved

No part of this publication may be reproduced, stored in a retrieval system or transmitted in any form or by any means electronic, mechanical, photocopying, recording or otherwise, without the prior permission of the publisher.

This book was designed and produced by Quarto Publishing plc The Old Brewery, 6 Blundell Street, London N7 9BH

> Senior Editor Sandy Shepherd Art Editor Gill Elsbury

Editors Hazel Harrison, Ricki Ostrov, Eleanor van Zandt

Designer Michelle Stamp Design Assistant Iona McGlashan

Picture Researcher Penny Grant Photographer John Wyand Paste-up Patrizio Semproni

Art Director Moira Clinch Executive Art Director Alastair Campbell Editorial Director Carolyn King

Typeset by QV Typesetting Ltd and Text Filmsetters Manufactured in Hong Kong by Regent Publishing Services Ltd Printed by Leefung-Asco Printers Ltd, Hong Kong

CONTENTS

	Acknowledgements
145	xəpul
134	Glossary
156	Square pegs in round holes
150	Any colour will do
116	Follow the yellow brick road
96	The colour of your money
87	Seeing red!
94	Introduction
	OWTTAA9 —
99	Have any colour you like so long as it's black,
38	But grey is a colour!
	Why can't I use Gill Sans Extra Bold Condensed?
54	01 1 011 2 1 2 0 1110
12 24	Forget the words – enjoy their shape
15	Forget the words - enjoy their shape

INTRODUCTION

the liberty of suggesting alternative designs). lyzed their designs and use of type and colour (and in some cases have taken book I've selected examples from well-known design groups and have anaon T-shirts to billboard ads to corporate identity schemes. Throughout the marker suitability of colours and typefaces for a range of designs — from logos work; how to determine type weight, line teed and line spacing; and the everyone here: explanations of terminology, examples of the finest design the visual communication industry in all its forms. There is something for connected with, have an appreciation of, or wish to become acquainted with ively with colour. However, I intended it to be of interest to all who are with the purpose of illustrating the infinite possibilities of using type creat-I wrote this book with the typographer/designer and design student in mind,

the reason for illegibility is obvious, but in other instances it is not. For have excellent legibility whereas others are virtually unreadable. Sometimes altering the interline spacing. We'll look into the reasons why some typefaces page, by changing the size of the type in relationship to its format and by You will see how tonal greys can be varied by using different typefaces on a

example, a designer might have chosen to have small white type reversed out of a black background, which looked perfect at the artwork stage where, as you would expect, quality was of the essence. But what was overlooked was the fact that the final product had to be reproduced on low-quality newsprint, and in the final result the high degree of ink absorption caused the delicate typographic characters to be filled in. 'Obvious!' you may think, but it happens far too frequently.

I will also discuss the range of considerations that have to be made when choosing colour, from the simple guidelines of the recessive nature of blue, and the dominant effect of bright reds and oranges, to the messages conveyed by different colours, to the subtlety of colour associations with appropriate products and services.

The fact that one man in ten has some degree of colour blindness should also not be ignored. Although it would be impractical to design totally for this handicap, an understanding of its manifestations would benefit all designers involved with colour choice. It is not particularly wise to specify one colour to be overprinted with another colour that is invisible to a sizeable proportion of the populace!

In general I've tried to present this book in direct, simple terms without either omitting important aspects of the subject, or insulting the intelligence of the professional with too many elementary examples. The book is intended as a working tool at every level and I hope that the many illustrative examples will inspire all designers and typographers, whatever their level of experience.

PART ONE

TYPE Making it work for you

P art One: Introduction

I have divided this book into two sections because it seemed logical to deal with typography and the black letter form first, and then to proceed to the ways in which colour affects type and works together with it to put across a message.

In this part, I start with the basics by looking at type purely as an abstract form and the ways in which its shapes can be manipulated. This is followed by a series of guidelines on how to choose the most appropriate typeface for any particular job. I then go on to explain how to achieve an extensive value range within type. Part One concludes with demonstrations of type used with different colours with comments on why the examples do and don't work.

For the benefit of the non-typographer I feel that a list of basic terminology would be useful within this section. (For a more thorough and detailed list of typographic procedures and terms there is both an extensive appendix and a glossary at the back of the book.) A knowledge of these few terms will enable you to grasp the jargon with a greater degree of fluency than you had before and so increase your enjoyment of this book. So, here are some elementary terms which cover the styles and characteristics of the basic letter form.

Type size refers to the overall depth of the typeface, and includes a measure of space above and below the actual letter form, which historically corresponds with the piece of metal on which the type character used to sit. It is not to be confused with either x-height or cap height. The measurement of the type size is denoted by the point or millimetre.

There is another method of measuring type. Specified as *key size*, it is calculated by the height of the capital letters, instead of the overall depth of the characters. (It is important to note, however, that the ascenders of some typefaces actually rise above the line of the top of the cap height.) It is the ideal system for mixing different faces on the base line, and ensures consistency of cap height.

Most typefaces are part of what is known as 'type families'. Each family is one basic design developed and modified in many ways to provide a greater choice and flexibility for the designer during the design process.

For example, if we take one of the most popular sans serif typefaces, *Univers*, we can see its development from the standard form into a huge range of variations, at the same time maintaining its original feel. These modifications are labelled according to standard terms (see table opposite).

We can then take the first nine examples a stage further by italicizing them. We now have 18 variations from one basic form. This can be extended still further by italicization, which would bring our total number of variations to 36. Further modifications are possible, depending upon type-face suitability, such as *Outline*. The advantage of all these variations to designers and typographers is that they allow them to create variety without producing a bewildering confusion of styles.

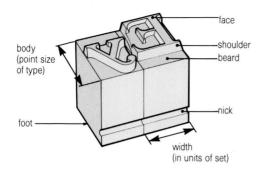

Type terminology derives from original setting in metal type.

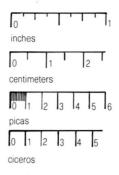

Differing methods for measuring type.

Roman

Italic

Serif

Sans Serif

Letters which stand up straight are called *Roman*, and those that slope forward are called *Italic*.

Almost all type can be categorized into two basic kinds of typeface - Serif and Sans Serif. The serif letter form is distinguished by a short stroke that projects from the ends of the character. Those letter forms without the short stroke are known as Sans Serif, from the French word sans, meaning without.

Light

Light Condensed

Light Expanded

Medium

Medium Condensed

Medium Expanded

Bold

Bold Condensed

Bold Expanded

Light Italic

Light Condensed Italic

Light Italic Expanded

Medium Italic

Medium Condensed Italic

Medium Italic Expanded

Bold Italic

Bold Condensed Italic

Bold Italic Expanded

- * Ultra Light
- * Ultra Light Condensed
- *Ultra Light Expanded

Extra Bold

Extra Bold Expanded
Extra Bold Expanded

- *Ultra Bold
- * Ultra Bold Condensed
- *Ultra Bold Expanded

* These examples are set in Helvetica, as the full range of styles was not available in Univers.

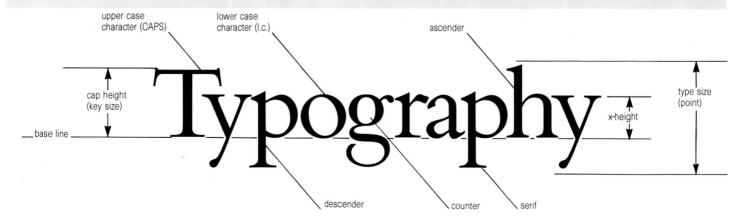

Forget the words - enjoy their shape

boo Iilli

Above One of the many considerations typographers encounter during their design work is how to deal with the different shapes caused by various character combinations. In the above example of Avant Garde we have the two extremes: consecutive round and consecutive vertical stress characters. When vertical characters occur together in a word extra space needs to be placed between them and when round characters occur together the space between them is reduced.

Well, perhaps the professional designer shouldn't forget the words, but the sentiment is correct. Good typography is to do with shape, balance, and colour. Always be aware of the shape your type makes. The use, or misuse, of the alphabet, could be the difference between failure and award-winning design.

But what is the alphabet? When you think about it, all that we have is a collection of abstract shapes which, when placed together in various combinations, convey messages that enable us to communicate with each other. Through the brilliant imaginations of type designers, many of these

basic characters have become beautiful forms. With these shapes designers can create even more complicated and adventurous imagery, sometimes to resolve a graphic problem, other times purely as a fine art statement.

Bob Farber, who was until recently the art director of the International Typeface Corporation's journal, U. & l.c., is one typographer who finds relaxation in treating type in this manner. By pursuing the very simple principles of repeat, mirror and reverse, Farber produced a series of colourful abstract images for the journal using only the basic letter forms of the alphabet.

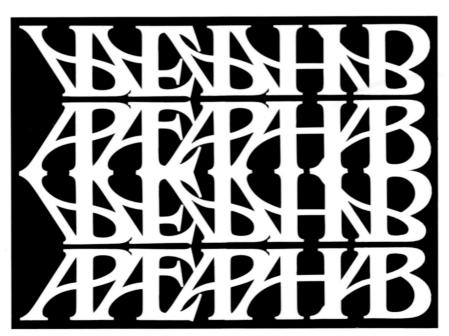

■ **Left** Bob Farber's creative design using mirrored characters from the ITC typeface, Benguiat.

I have included three of his designs. One of them, a striking example, was used for the front cover of one of the *ITC* journals. *ITC's* own description of the piece went as follows:

TYPE AS ART AS FUN.

Sometimes the most fun is enjoyed doing something you are not supposed to do. Ask any child, if you don't recall your own childhood. Bob Farber, one of our truly great problem solvers with type is quick to tell you, type is meant to be read. That's why he's had so much fun creating typographic images that not only can't be read but aren't intended for reading.

Here he's taken some of the logos or variant characters from the ITC Benguiat family and lined them up like Narcissus at the edge of the stream. Narcissus, you recall, was that Greek lad who so admired himself that he spent much of his time looking at his image in the water. The gods punished (rewarded?) his vanity by turning him into a streamside flower nodding towards its reflection.

Just as the narcissus is a thing of beauty, so is this interlaced and multiple mirrored set of letters. You can identify the individual letters, but why bother? Just let your eyes feast on the flowing, joyous curves and the shapes they form.

Edward Gottschall: Editor

The addition of basic primary and secondary colours to a black and white design can produce equally vibrant results, as shown by the kaleidoscopic 'A' on the right (it's so basic — just seven *ITC Serif Gothic* letter A's in a circle).

But good design does not have to be complex. What could be simpler than the double *ITC Century 'Y'* shown (right)?

Such design concepts make ideal projects for newcomers to typography, enabling them to become acquainted with the practice of simultaneously handling colour and the typographic

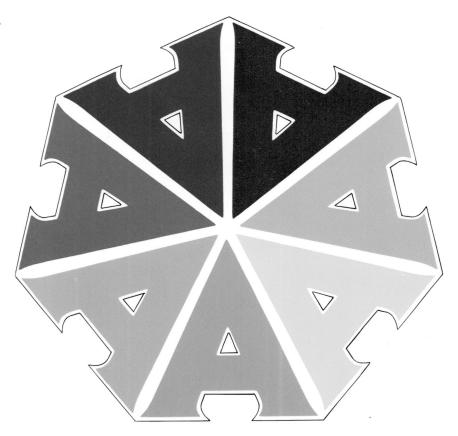

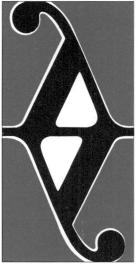

Above The second example of Bob Farber's creativity uses the ITC typeface Serif Gothic.

■ **Left** This third example illustrates the simple but effective use of the letter Y from the ITC Century typeface.

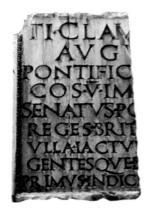

■ Above The shape of the characters in this Roman inscription derived initially from the brush strokes that were used to paint preliminary designs. Later they were modified by the chisel as letter forms were cut into stone. Serifs owe much to the directional action of the chisel.

form without having to worry at all about the restrictions normally encountered in everyday studio situations.

CALLIGRAPHY

Moving back in time you will find that there is nothing new in the marriage between art and typography. In oriental cultures calligraphy is a highly esteemed art form, based on centuries of tradition, fully integrated with other artistic skills and traditions.

The term calligraphy simply means beautiful writing, although its beauty does depend very much on the eye of the beholder, or personal taste. Just as many styles of art exist today, from the exceptionally clean and tight to the totally free and abstract, so it is with calligraphy.

Modern calligraphy has a definitely formal basis in the traditions of the Romans and early Christians. During the period of the Roman Empire our standard alphabet was developed and transmitted

aBcoefghíjk Impoporst uvuxyz 1234567890 &!!£\$(.;;)

■ Above The American Uncial typeface is based upon the original alphabets developed by the Romans in the early fourth century AD.

■ Right This example of a sixteenth-century manuscript is attractively enclosed in solidly coloured and richly designed borders surrounding the text. to the conquered lands of Europe and, subsequently, developed by the teaching of Christianity.

The Romans adopted the following characters from the Greek alphabet — ABEHIKMNOTX YZ— without modification, and remodelled the following—CDGLPRS—to suit their own language. With the re-introduction of F, Q and V, previously discarded by the Greeks, virtually all our present-day alphabet existed, with only J, U and W to be added at a later date. By the early days of Christianity the Romans had established not just this formal alphabet, but several variations of writing, including the introduction of the serif.

By the early fourth century AD the Romans had developed a new script, the uncial, which became

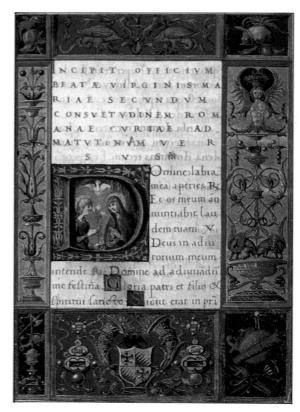

the main face of the early writings. With the inclusion of both descenders and ascenders, our present-day upper and lower case emerged: the typeface American Uncial (far left below), is based on these early styles.

By the tenth century, through the influence of the Church, all the elements of modern writing were in evidence. There followed a tremendously rich period in the development of illumination, which has left a wonderful legacy of letter forms and scripts.

Today these same calligraphic skills are being revived, not so much as a commercial trade (although there are professional calligraphers), but more as an art form. The exciting aspect of present-day calligraphy is the tremendous variety of styles and media with which it is executed — as I'm sure you'll agree from the examples shown.

As you can see from the development within the examples here, it has become increasingly difficult — not that it really matters — to see where

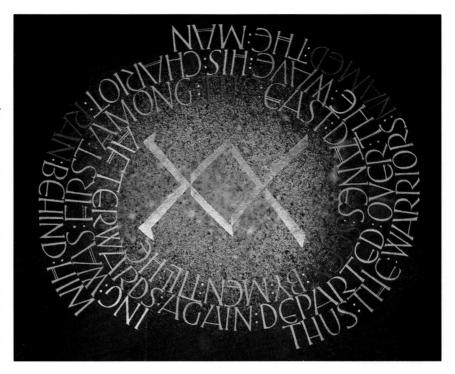

Left A lovely example of calligraphic technique by the American artist Georgia Deaver. She has cleverly set up a contrast between the freedom of the title and the tight control and condensed style of the body copy. Notice too how each character in the title sits above each column, but by allowing the flourishes to extend beyond their parameters she has prevented the columns from becoming too strong and unbalancing the design.

Above This effective combination of different motifs written with a quill in silver and gold leaf and gouache is stylistically similar to the Bob Farber examples on the preceding pages.

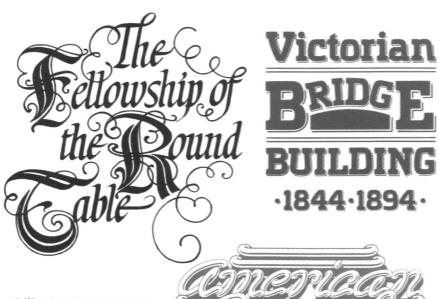

When Letraset want to promote one of their new typefaces they often ask the designer to produce a 'wordset' to illustrate how they see their initial concept working in terms of words and their shapes. 'The Fellowship of the Round Table' is a wordset designed by typographer David Harris in his own Musisca typeface. 'Victorian Bridge Building' is designed by Tony Geddes in his own creation, Senator Display, and the third example, 'American Cars of the 50s', is in Vegas, designed by David Quay.

calligraphy ends, and conventional typographic letter forms begin. In many respects it is a natural progression from one to the other.

DRY TRANSFER LETTERS

The advent of the dry transfer letter form has, to a large extent, helped to bring together calligraphy and the more formal typefaces, giving designers the facility to achieve their visual aspirations with greater speed and efficiency. As a means of illustrating the infinite variety of design that can be created from "rub-down" letter forms, Letraset, the British graphic arts company and producers of transfer lettering, often commissions the finest typographers to design new typefaces in dry transfer and to demonstrate the wonderful range

of layout and design that can be achieved by the skilfull manipulation of those same letter forms.

Typographer *David Harris* designed a particular face, which he called *Musisca*. It is an excellent example of how the art of calligraphy can be developed into a formal script combining the freedom of the hand-drawn letter together with the control of a formal typeface.

David also created an attractive wordset on the theme 'The Fellowship of the Round Table' using his *Musisca* typeface (shown left).

COUNTER SHAPES

Returning to our theme 'Forget the words — enjoy their shape', it is always important to consider not just the shape that the individual characters or words create but the spaces around and within those actual shapes. Look carefully at the shape of the lower case *Helvetica* 's', (shown below).

If we close in on the character, reverse it from black to white and spin it through 90°, we become aware of what looks like a new image. But it is not really new; it is only the relationship of black to white and position of the letter that has altered.

SHAPING LOGOS

The art of the hand-drawn letter form is often applied to logotype design. Even those faces based on the sans serif form often contain elements of hand drawing to achieve that little bit extra in terms of a unique statement. It is always interesting

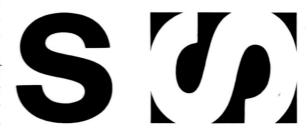

themselves. effectively as the characters characters can be used just as the space is between the Photo is a good example of how W not agypee for M above The logotype for M

pnsiuess. symbolize the nature of its associated with the firm and to ing blocks to form the letter Y cessfully used a motif of build-Yates Architects Inc. has suc-

Left: The company Richard

idea of home-building. shapes, which symbolize the

have introduced basic geometric

Minale, Tattersfield & Partners -

furniture store, was based on the

derivative. The designers -

typeface Frutiger, a Gill Sans

design for Heal's, the British

Right This colourful logo

the brush lettering below it.

'CERTAIN', which is set in a

for the violence and freedom of

Cannon Productions. The word

Girvin Design in Seattle, done for

use of contrast, this time by Tim

Below This is another effective

Perpetua derivative, provides a foil

store, and Tim Girvin himself was famous New York department produced for Bloomingdale's, the of its promotional function. It was graphy can be without losing any how free and decorative typo-Tim Girvin Design, illustrates just design by the Seattle company, eninniw-brawe sidT #al 🖀

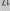

Friz Quadra.

The typeface is a modified without detracting from legibility: forming the bar of the letter, allowed to partially cover the A, C. The horse's body has been been used to form the character silhouette of a horse's head has famed for its white horses. The

Camargue, an area of France

fashion accessories which was of this logotype for a range of

Partners were also the designers

Above Minale, Tattersfield &

E:MARGUE

marketed under the name of

to see what methods different designers use when they approach logotype design. Each has his or her own style and way of working, but more often than not there will be a common approach of logic and development to the work.

CKEVLINE TYPEFACES

As you've seen from some of the calligraphic examples, type does not have to be either rigid or formal. There are many ways of creating exciting typography from whatever materials and media you think fit. For instance, interesting textures can be made by painting with ink and then allowing the paper to wrinkle, or by deliberately underink paper to wrinkle, or by deliberately underinking old-style wooden display type. This page provides a few ideas.

with ink and applying it to low-

involved loading a large brush

Sample. trations were done by Paul by Steve Grime, and the illusart direction and typography was just the right size and weight. The tonal colour of the body copy is around unusual shapes, and the layout and how to work type an excellent example of page letters they have created it's also Belding. Apart from the delightful advertising agency, hoote, Cone & the London branch of the four-part alphabet produced by to hed sew eyewriA deiting not winning full-page advertisement -brawe ne to lietab cirl This detail of an award-

weight tracing paper, which

Far right Old Style wooden display type, much used before the days of photographic heading ing imagery, especially when the blocks are underinked and cause the ink to break up.

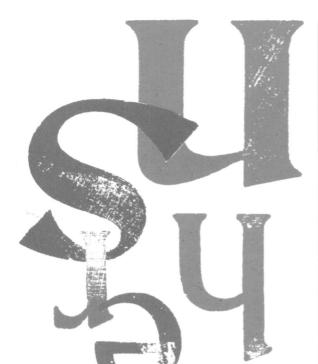

Right Another example of a fun typeface, this time a personal greetings card I produced recently for my own family.

Left A simple but effective design to commemorate 25 years of business in the United kingdom for the international computer company Hewlett-Packsid. It was produced for the company by the London design group The Partners, and contrasts a simple condensed sans serif face with condensed sans serif face with condensed sans serif sace with missing the freedom of the numerals,

components.

HEWLETT-PACKARD LTD

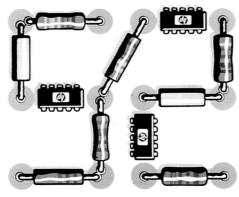

YEARS OF COMMITMENT

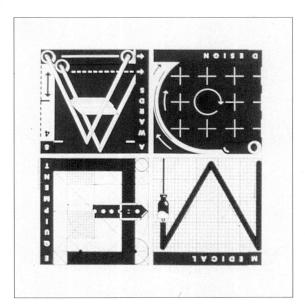

Right The design for this invitation to an art exhibition called Dutch Crossing uses an interesting combination of wax resist and woodcut lettlers. The whose work was presented, and the letter W for the Watermans gallery where the exhibition took place.

Above This two-colour typographic design was created by Grundy & Northedge to Besign Award' bursary scheme. It cleverly incorporates images from medical technology.

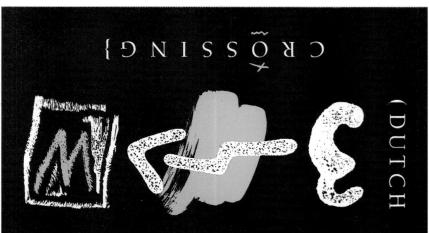

Expanded by 60%

Typography

Condensed by 60%

Туродгарћу

Expanded by 40%

Condensed by 40%

Туродгарћу

Typography

Condensed by 20%

Expanded by 20%

<u>Ι</u>λboθιαρhγ

Туродгарћу

No modification

No modification

Right The following examples of the word 'Typography' have been set in Univers medium and electronically modified on a Linotron 202 computer typesetter.

<u>Ι</u>λbοθιαρhy <u>Ι</u>γροθιαρhy

The re-proportioning of type is now very common but sadly often abused. Headline machines and most modern computer typesetters can condense,

WODIEXING TYPE

Having looked closely at various methods of creating type in an extremely free and imaginative way we'll now move toward the other extreme — tight control by means of camera distortion and graphics modification.

As you will no doubt appreciate, one of the major factors of good type design is the relationship between the weight of the stem (vertical) and bar (horizontal) of the letter form. As soon as you start to distort the character by either electronic or photographic means, the relationship between the

expand, italicize and back slant, but it the designer is lacking in his or her feel for typographic proportion, the result is imbalance and appalling proportions of type characters.

stem and bar will alter and, depending on the actual typeface, there will come a point when the balance between the two is wrong. In the examples shown below notice the point where the visual relationship between the stem and bar suffers, making the distortion increasingly unacceptable. Just compare the distorted type with the true designs of *condensed*, *expanded and italic*.

Of course this doesn't mean that you shouldn't modify type but it is important that you be dis-

cerning. Large headlines can often come out stronger with just a nudge here and there, as the examples below show.

There is another machine available to the designer that can be extremely useful, especially when designing logos. It is generally known as a graphics modifier and has the ability to outline, inline, and drop shadow in whatever combinations you require. Because of its mechanical base it is accurate and produces uniformity of line.

Standard Korinna Extra Bold

With drop shadow

With box line

With double outline

With double outline plus decorative screen.

Typography

No modification

Typography

10% Slant

Typography

20% Slant

Typography

30% Slant

Above right Compare the true Univers with the electronically modified version. Note how the basic character of the type is distorted and lost. The greater the modification the greater the degree of 'bastardization' of the

original, leading to unacceptable standards of typographic form and taste.

Typography

True Univers medium condensed

Typography

Electronically condensed Univers

Typography

True Univers medium expanded

Typography

Electronically expanded Univers

Typography

True Univers medium italic

Typography

Electronically italicized University

There are times, however, when you may want to distort a typeface deliberately — sometimes uniformly, other times in a totally free manner. Some headline machines are equipped with a special lens that allows you to set type in circles, in a dip-arch movement or to create a balloon effect. Box perspective is also possible, as are converging perspective and general distortions.

The possibilities of distorting typefaces to create different effects by using special lenses, computers and other techniques are almost limitless. This page provides just a few examples.

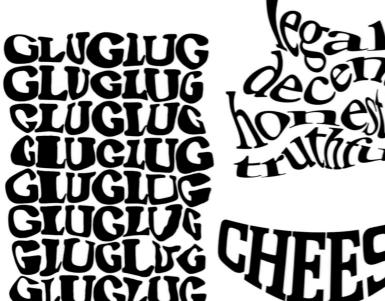

Herb Lubalin

This chapter would not be complete without examples of one of the greatest typographic masters of our time, the American typographer *Herb Lubalin*. He produced numerous designs for countless clients, far too many to include in one small section of any book. Some of these designs are well known but, as with any form of real art, you can't see them too often. Words from me would be superfluous, so just 'enjoy their shape'.

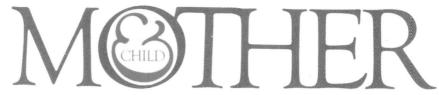

AAN SARDE SHC

Grumblaches.

MARAIAGE

Families

Herb Lubalin's designs are world famous and he is known particularly for his imaginative use of letters and ideas. In the design 'Oh! Ah!' he used the initials of the photographer Anthony Hyde and his representative Li-Lian Oh as a means of introducing them to their prospective clients. The Grumbacher logo was designed for the company of that name. which sells art materials. 'Mother & Child', probably Lubalin's most famous piece and the designer's own personal favourite was, ironically, for a magazine that was never published. The design 'Avant Garde' was originally a masthead for the magazine of the same name, but led Lubalin to develop an entirely new typeface - Avant Garde Gothic.

W hy can't I use Gill Sans Extra Bold Condensed?

Countless typefaces have been developed over the years, particularly over the last two decades, because creative designers are continually seeking new and more exciting ways of creating mood and impact. Choosing the correct typeface can be a daunting task for the inexperienced designer where to start? what size? what weight? and oh, those type catalogues! There are literally thousands of faces to choose from, which can make the whole process all so intimidating. It can at times be something of a major task for even the most experienced designer to produce something different, so what chance has the novice typographer? This vast range of type styles often has differences so minute that experienced typographers have to look twice to spot the subtle variations. So what is the answer?

The first thing is not to panic! Most experienced designers will restrict their choice of faces to no more than a dozen or so working styles, although even this can lead to an exceptionally large choice when all the family variations are taken into account.

CATEGORIES OF TYPEFACES

When building a basic library, look for variation and contrast. The simplest approach is to study how the various typefaces are categorized and what the basic groupings are. The identifying characteristics of most typefaces can be grouped into six easily-understood categories. Along with modifications of the former, another four are created.

When compiling a working list of faces it is a good idea to include a range of examples from each of the various groupings. A basic working list could look something like that below and on the opposite page.

The six basic typefaces are: Old Style Serif, Modern Serif, Square Serif, Sans Serif, Scripts, Stylistic/Novelty and the four modifications are: Modified Sans Serif, Outline/Inline, Connecting Scripts, Non-Connecting Scripts.

With the exception of some of the script examples, all the examples opposite contain the normal variations of light, bold, condensed, italic, etc. These nineteen examples provide not just an excellent foundation for the beginner, but a sound working basis for the professional designer, too.

OLD STYLE SERIF

Caslon

Garamond

Plantin

MODERN SERIF

Bodoni Century Schoolbook Tiffany

no end to these wonderful works of art. salayy-adfit "barudluos", "baravoosib ad ot briting that can be found. There are many more just are just a small portion of the kinds of letter-forms sculptures out of these letters. Those shown here How many ways can you draw the letters of the alphabet? The great type designers of today have

Medici Script Zapf Chancery

NON-CONNECLING SCEIBL

thrist historia

Erush Script

A Galliard Ultra Italic B Veljovic

Black N Galliard Ultra Italic

Condensed I Isbell Heavy

Italic H Benguiat Medium

L Zapf Chancery Bold M Galliard

J Barcelona Bold K Isbell Medium

F labell Bold G Usherwood Black

D Galliard Bold E Benguiat Book

Black Italic C Fenice Ultra Italic

CONNECTING SCRIPT

V Veljovic Bold W Novarese Bold Regular U Veljovic Black Italic S Cushing Medium T Newtext Garde Book R Galliard Roman P Novarese Bold Italic Q Avant O Novarese Bold Italic

Italic X Isbell Heavy Italic Y Isbell

Baker Signet Souvenir Gothic Optima

WODILIED SANS SERIF

Gill Sans

Futura

Univers

2V/12 SEKIH

Rockwell

Egyptian

Clarendon

SQUARE SERIF

Medium Z Isbell Bold Italic

Square Serif: Rockwell

far greater importance. tising where mood and expression are of ter. They are much more suited to adverright appearance in extensive text matexamples, square serifs rarely create the a small radius. Unlike the previous two join the main stem at a sharp angle or with vertical and horizontal strokes. The serifs serif, with little contrast between the strong, heavily blocked design of the The main feature of this category is the

Sans Serif: Unica

work well in any situation. stress can be tiring on the eyes, it can volumes of text, where its vertical egories, with the exception of large fore the most versatile of all the catlight through to ultra bold. It is thereto large family variations, from ultra ity of design in this group lends itself ric designs are common. The simplicvisually equal in weight, and geomet-The strokes of this face tend to be

Stylistic/Novelty: Neue Lutherische

short phrases. normally used for single words only or in very because of their intricate design features and are special effects. They work better in large sizes decorative designs that create impact, mood or unique and highly distinctive, often consisting of fitting any of the previous headings. Even are This category usually applies to any typeface not Fraktur

> fidence grows. easy matter to extend your vocabulary as your conbasic, if slightly limited range of faces, it is a fairly Once you have become fully conversant with a

TYPE FAMILIES CHARACTERISTICS OF THE BASIC

sideration is 'If it looks right, it is right'. Rules are made to be broken and the only real confor each type category are generalizations only. You must appreciate that the situations suggested

Old Style Serif: Caslon

large blocks of text. other forms of literature in which there are them highly suitable for use in books and styles they are easy to read. This makes proportion. In their light and medium curve, and the letters are generally of open The serifs normally join the stem with a with relatively uniform stroke widths. include a boldness and strength of feature The characteristics of the Old Style Senf

Modern Serif: Century

ments and leaflets. text such as those found in advertisebetter suited to shorter passages of the bold members of this family are too, can be used for book text although is also known as Transitional Style. It, symmetrically located. This category the Modern Serif in round letters is serif to the stem). The weight stress of bracketing (the curve that links the thick and thin strokes, with little or no there is a strong contrast between Unlike the Old Style Serif, in this face

Modified Sans Serif: Optima

Although Sans Serif in appearance, the Modified Sans Serif design contains either small flared strokes or minute serifs, along with the greater variation and contrast between the thick and thin strokes that are typical of the serif faces. It is not quite as versatile as the basic sans serif, and is better suited to larger areas of text because the small flare of the suggested serif reduces vertical stress and thus aids readability.

Outline/Inline:

Times Modern Black Outline

These designs are, very often, created from existing type faces that have been modified by outlines, inlines, shadows, contours or a combination of any of these features. They are restricted mainly to headlines and product names.

Connecting Scripts: English Script

This group of modifications emulates the cursive writing of calligraphy and the natural flow of handwriting. Although it has the consistency of type design it is not normally suitable for text setting because the designs are usually of pen or brushstroke origin. They often work well on packaging and other forms of "below the line material.

Non-Connecting Scripts:

Zapf Chancery

A great deal of variety is contained within this group; it includes both non-connecting hand-drawn letter forms and ornate, formal typefaces. The designs can be based on pen- or brushwork, black letter, informal scripts or elaborate designs. Legibility can suffer with some of these designs, particularly with the black letter variations, and these should be used with care. These scripts are used in the same cases as those of the connecting scripts.

> Below This detail from a poster designed by Robert Wakeman, for Graphic Technology, displays a range of faces. all of which can be used in a corporate design, depending on the image the company wants to put across.

When typeface companies set sample showings of their typeface collections they usually display them by setting famous quotations or wise sayings. They dazzle the eye with typographical layouts highlighting the theatre and the fine arts, as well as samples of menus or recipes found in each beat.

as well as samples of menus or recipes found in cookbooks.

That's all nice and pretty, and it does give the creative people some ideas of how the type will look. But what about the business word! It has large and small corporations which spend millions of dollars a year on advertising, promotional campaigns, brochures, annual reports—the bit goes on and on. Decease of the corporate world requires a different kind of talent from the ones mentioned at the onset. The type should not dazzle the eye, but look clean, crisp and important.

onset. The type should not dazzie the eye but look clean, crisp and important. Where is it written that all corporate ab have to be set in Futura extra-bold condensed for the headline, and Century oldstyle, Times Roman, or Helvetica as

oldstyle, Times Roman, or Helvetica as the body text? Setting corporate ads in these typefaces as body texts, you run the risk of having your ad look just like the editorial material of the publication you've placed the adin.

In recent times, there have been typefaces designed that can be used to give businesses that clean corporate look, With so much brochare work being done these days, there's no end to simple to the control of the co

BUSINESS

aphy shop. That's not true. Actually, the

THE ECONOMY

SUITING THE FACE TO THE PRODUCT

Much of the art of choosing the correct typeface and weight lies in the combination of product association with the designer's aesthetic judgement. For example, to promote jewellery, a designer would consider a choice of delicate faces, probably a fine serif or an italic. For directional

signs or commands such as *Keep Left, Stop,* etc., a strong sans serif face in its semi-bold or bold style would be more suitable. Then there's typography to advertise engineering products. Because the face needs to suggest strength and power, delicate serifs are less appropriate than a stronger square serif such as *Rockwell Bold* or *Clarendon Medium*.

JEMZON

■ Above and right In these examples, the message is clear and uncluttered. The generous use of space around the words in both cases ensures readability, and the design touches are delightfully humorous, with clever use made of a giraffe's neck in the F.

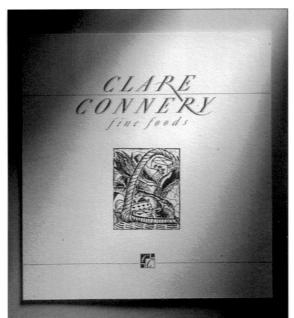

■ Above Jewson is a leading British firm of timber and building materials. The inspiration and starting point for their logo was a carpenter's rule, which creates a solid, strong typeface, appropriate to the nature of their industry.

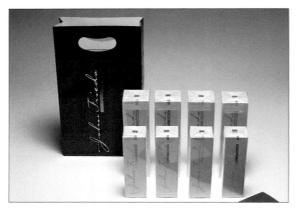

- Left The logo script on this hair-care packaging was designed by Trickett & Webb for a company called John Frieda. The script with its ribbon motif gives a personal touch and an upmarket image.
- Above This design, by Coley, Porter, Bell, was done for Clare Connery, the Irish celebrity cook. as part of a design scheme for her chain of delicatessens in Belfast. Notice the fine decorative use of the leg on the R.

Above The Rockwell typeface, although strong, has a cluttered look because of its heavy serifs. If a basic sans serif had been used, such as Helvetica, it would have been far more successful, as the extra white space would have increased legibility and impact.

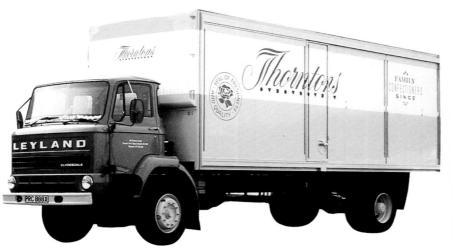

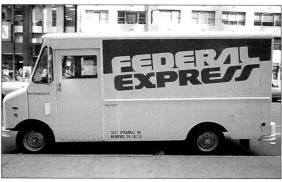

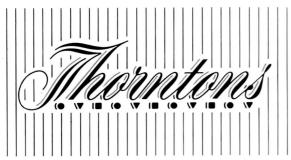

Left and above Yet another example of excellent design work from Minale, Tattersfield & Partners. Just as the Jewson logo suggests building and construction, this one shouts out 'confectionery', even to those who do not know that Thorntons are makers of high-quality chocolates. The colour and the flowing script both send messages of delicious sweetness, which are reinforced by the decorative geometric shapes sitting beneath the script.

Above and above left An interesting comparison can be seen in the faces used on these delivery vans. In the Thorntons example, the van livery has been properly thought out and works well, whereas the Federal Express livery is a rather clumsy attempt at trying to suggest speed of operation, using the italic double S. However, it fails to do so because the typography as a whole has a heavy, static quality.

Right and below Two interesting approaches to page layout. The Pentagram piece, right, is typical of a situation where numerous illustrations and ample text have to be placed within a limited area. By positioning the map centrally and working the other elements around it the designer has kept the layout fresh and uncluttered. The captions are set in a smaller size than the text, which creates a good tonal contrast. This is further strengthened by the use of tints. The example below, an annual report to company staff designed by Trickett & Webb, uses two-colour printing only. White space has been used well, and the designer has spaced out the main title effectively. Notice also the nice touch of the raised initial A to begin the main text.

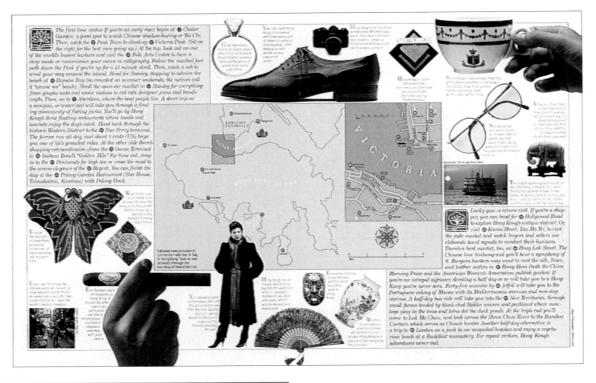

SUITABLE FACES

When determining suitable typefaces for running text you can't really lay down rules, only basic guidelines. Generally speaking, medium weight serif faces work better than sans faces. This is due to their greater horizontal stress, which guides the eye effortlessly across the page.

For captions and annotations, try and choose a face which contrasts with the text style; for example, if the running text is set in a medium serif, consider sans, italic, or condensed faces, or a heavier weight, which will stand out against the body text.

There are not really any correct or incorrect faces for running text, because the colour of all typefaces can be changed to improve legibility by varying line and character spacing.

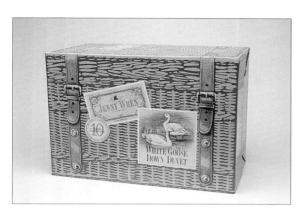

Left The box for Dorma 'Jenny Wren' duvets, designed by Trickett & Webb, is a good example of how proportionately small the product description and company name can become without weakening the message. If the type were to be larger in this case the message would become crude and ugly.

- Above Tricket & Webb used a 1920s poster design and 1940s book cover design for a product range of 'Men's gifts'. In the example above the driver's cap clips the type without affecting legibility. In the adjacent example, however, the placing of the white lettering of the word 'outfit' against the cream background has undoubtedly reduced its legibility.
- Left Typography is subject to fashion just as any other form of design is, as can be seen by these two poster designs from The Partners. The lefthand image is clean, modern and dramatic, creating its mood by the use of photography, and the colours black, white and red. The righthand image typifies a current interest in typography, design and illustration from the 1950s.

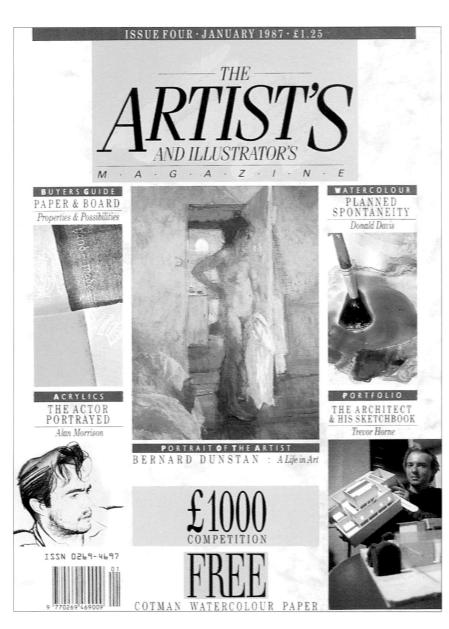

■ Above The cover of the January issue of *The Artist's and Illustrator's Magazine* uses a modified Walbaum italic masthead combined with openly spaced sans. The reverse blocks of Gill work well above the electronically condensed Century, balancing weight and stress well.

MIXING TYPEFACES

Once you have committed a basic selection of faces to memory, the next stage is to combine the various styles in a cohesive and controlled manner. If you stick to using variations within a single family grouping you will always be safe in the knowledge that they are compatible. But how do you successfully combine different faces from other family groups without losing continuity of design and good taste? The easiest way to approach this design problem is to start by combining opposites. A standard sans serif such as *Gill Sans*, *Helvetica*, or *Univers*, will blend with virtually any serif face, whereas you would not use *Helvetica* with *Univers* or another similar sans serif. They are far too close in style to work.

Within the vast range of serif typefaces, many are quite compatible, and it is often needless to resort to finding their opposite in another face. Their contrasting design features add colour and life to a design when they are combined. Most of the square serifs work well with the modern serifs such as *Times* and *Baskerville*.

The various areas of design where typeface mixing works well can be simplified quite easily.

Advertising: The most common form of mixing in advertising is for the headline to be set in a strong sans serif face with the text in a suitable book, or text, face. The Old Style *Garamond* is a popular text choice, and so are the moderns like *Baskerville* and *Century*. This combination can also work well in reverse, when you use a strong serif for the headline followed by sans serif text, although it is less common. Depending upon the style of the advertisement, virtually any weight of typeface can be used for the headline, but with the text, or body copy, there does come a point where legibility suffers if the weight and tonal colour of the type

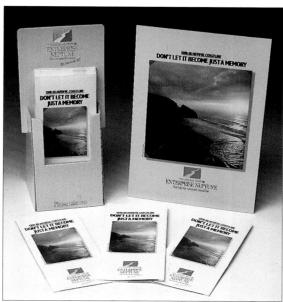

go beyond a certain level. This point of reduced legibility can only be assessed in the context of the advertisement and its relationship to the rest

of the design.

Many advertisements, particularly those concerned with trade magazines, contain reader reply coupons. This is another area of design where a change of typeface can add contrast and variety. In these coupons a possible third typeface is often incorporated when the company's name and address have a specific style or face. But do beware — there are few occasions when more than two family types work well within one design. When you consider the variations of weight and italicization within any one group there is plenty of choice without having to use faces from other groups.

■ Left This simple but effective copy for Enterprise Neptune is created by using a strong sans serif headline run in Gill Sans Bold Condensed with a contrasting serif set in Century Nova.

■ **Below** Recipes and menus are ideal for type mixing. This example by typographers Max and Hunter Brown illustrates this point. They have successfully incorporated a hand-drawn title

heading with a serif text in both medium, bold and italic plus a sans serif face set at intervals throughout the text.

■ Right This poster of the ballet dancer Baryshnikov illustrates how creative mixing can be introduced into the minimum of copy: different styles of type have been used within just one word. The choice of a simple sans for the remaining text gives just the right balance – a serif could have been distracting. The poster was designed by Bob Appleton of Appleton Design for the Hartford Ballet.

■ Above Type mixing is not all that common on billboards because there is usually relatively little copy. When it does occur it is often used to contrast the logotype with the main typeface, as in this stunning example for Greenpeace. The art direction was by Jeremy Pemberton of the Yellowhammer agency.

Billboard & Poster: If you were to distinguish between the billboard and the information poster you would find that the billboard is not normally a vehicle for type mixing. There is a general rule for billboards which says that the copy headline should be restricted to a short, crisp phrase of no more than nine words. The reasoning behind this is quite simple: most billboard sites are positioned along roads or highways, to be viewed by passing motorists who will have time to see only short, swift messages.

Type mixing can work on a billboard, but usually only when a word or the product logo is combined within the headline for effect or emphasis. There are, however, billboard sites such as bus and rail stations, pedestrian precincts and subways in positions frequented by pedestrians. In such situations copywriters have the opportunity to develop ideas that often result in a humorous approach aimed at bringing some light relief to waiting passengers and passing pedestrians. As with general advertising the combination of a

headline in one face followed by the text in another, can work well.

The purpose of a poster tends to be more informative than that of the larger billboard. Public service announcements, health information, theatre and film promotions are typical of its uses. More often than not it will appear indoors or in public places where people have time to read and digest its contents. This allows the designer the opportunity of providing the reader with a greater degree of information and the typographer greater scope for creativity. The same guidelines apply to poster layout as to advertising layout.

Corporate Identity: This type of brief is not really the occasion for exploiting a variety of weights and styles of typeface, but there is some room for a little variation within a corporate scheme. This frequently takes the form of a specific design for the company logo, often hand-drawn, beside a contrasting typeface for the address and general information details.

Above and left These two examples illustrate ways of mixing different sans serif typelaces. The imperial War Museum poster is a sa a logo for the museum by The Partners. The logo was then developed further by Grundy & Northedge to act as a brochure cover and letterhead for the cover and letterhead for the museum's forthcoming festival.

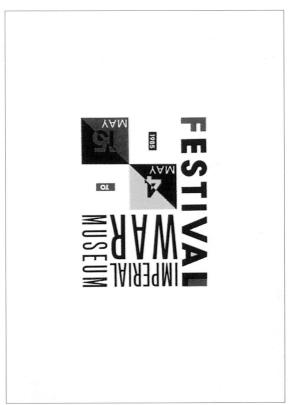

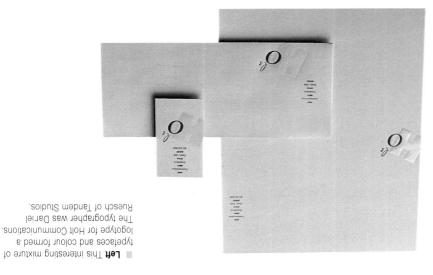

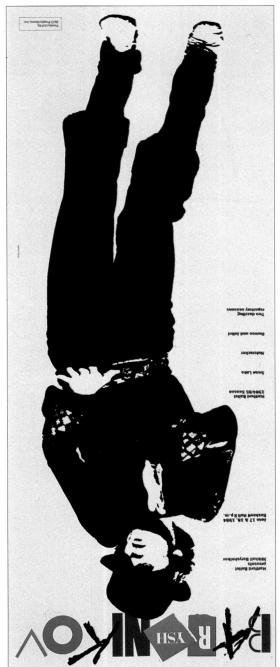

eral flow or context of the main text. or illustrative point is being made outside the genwithin the body copy when a change of emphasis captions. A change of face can also work well and choose a complementary sans serif face for the preferable to move away from the main text style ticular point. For that reason it is nearly always the main body to add clarity and emphasis to a paritalic might already have been incorporated within sion of the main text is used for captions, but the for illustrative captioning. Sometimes an italic vercommon. A change of style is definitely a good idea a size of annotation is readable; (mm) opt is quite condensed feel is desired. It's surprising how small Univers, or perhaps News Gothic if a slightly more mally be set in a basic sans serif such as Helvetica or

The general guidelines in the above examples can easily be applied to all the other areas of visual communication. In every one of them balance, contrast, legibility and visual interest are essential criteria.

TYPE VARIATIONS

and Berthold calls its version Akzidenz-Grotesk. now the name Triumvirate for its CRT machines, pugraphic uses the term Helios for its film founts and company Varityper uses the name Megaron, Comcompany's version is called Europa Grotesk, the it became available under license. The Scangraphic Foundry, has undergone subtle modifications since Haas Helvetica, for example, from the German Haas when a face is redrawn the name will also change. own version of the more popular faces. Often, licensed by the owner, whereas others create their Some manufacturers use only the original artwork within the same face from supplier to supplier. It is surprising how many variations there are point that typefaces are not always what they seem. To conclude this chapter it is worth making the

Print: General literature, brochure and illustrated book design are areas where the mixing of various typefaces is not only most common but also desirable. The general text is often set in a light, book serif style with introductory paragraphs in a heavier weight. Where subheadings occur they can be set in a different face, usually a sans serif, as can be the main headings. Annotations would note

Kight Menus always give designers an opportunity for creativity, and this example – from Steven Wedeen of Vaughn, Wedeen Creative, Inc. – is no exception. Each course is esperated by an appropriate logo, which adds life and fun to the basic concept, and the final result lacks nothing in spite of the fact.

Left This fine example of creative callignaphic techniques inked within a typographical layout comes from Pentagram UK. Votice hows a second and third colour and additional typefaces colour and additional typefaces have been used as captions between the two columns of main text.

Below From a two-column grid to a single-column structure. Paul Arden directed this double-page spread for Alexon's African tashion collection with photo-graphs by Richard Avedon and typography from Roger Kennedy of Sastchi & Sastchi. The large duantity of white space around the typography are all help to create above-average amount of spacing between lines all help to create the sophistication necessary to set off this stunning visual image.

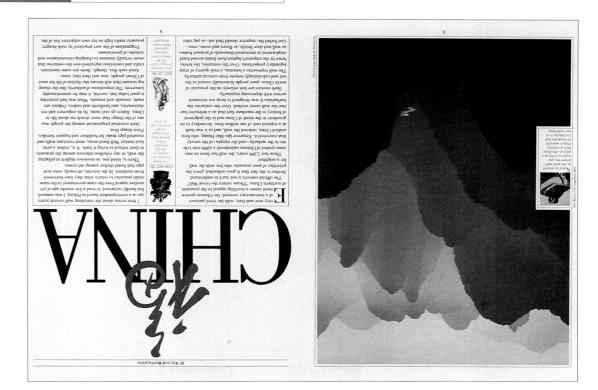

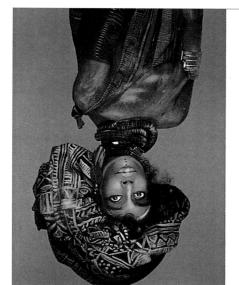

burs the chancer grandy in the bellje. The chancer has been approved. The chance is outstanding The eye popping, limb concounting ward of nargic and colour that is the tribal Lance of the Normada of the Normada of the Normada of the narrow of the chands of the studie owner of the results of the studies owner where on New York's Ever Side, Richard Aberdon the photographer Amo Tummin guited Aberdon the photographer Amo Tummin guited Cappot that salled "He man with guited Park Modalber the salled" The man with guited Woldaber the fact that the salled with the colours and primitive pattern wover in into oblevies partier.

This lack of standardization can cause problems, especially if creative requirements bring the designer into contact with a wide range of setting systems. The number of faces available will vary from manufacturer to manufacturer with most range. This means that when designers prepare visuals they must take into account the typographic range of their local suppliers. Because of this variation of style from the different sources it's ton of style from the different sources it's extremely important for the designer to have at extremely important for the designer to have at hand the relevant type specimen sheets.

design priorities, ie. **Priority 1.** Headline: The attention-grabber.

approach to layout, but has still obeyed the basic designer has moved away from the conventional but broken with understanding and skill. The have an example where the rules have been broken, appear at the head of the design. Here, however, we headline. You would normally expect a headline to headline, and also with the prominence of the with the strong vertical stress of the illustration and of italic in the body copy creates a subtle contrast loses none of its readability. Note also how the use tration to be the focal point, but at the same time body copy recedes just enough to allow the illus-Gothic Heavy. You can see how the weight of the in Souvenir Light Italic, Souvenir Demi Italic and Serif International Typeface Corporation's journal. It is set appeared in the June, 83 edition of U & Le., the The rather lovely piece of design work shown left First let me explain what I mean by tonal colour.

Not only does the typographer have to make a decision about the correct style of a typeface, but also about the correct weight and tonal colour. In this chapter we'll look into the effect that the right — and wrong — choices of typeface, and in particular spacing, have over the tonal colour of various styles of body setting. I'll be illustrating just how you can alter the tonal colour of any typeface by simply varying the letter, line and word spacing. I'll also demonstrate the importance of line length and the differences that light, medium, bold and italic the differences that light, medium, bold and italic availations have on the same copy.

interest. Priority 2. Illustration: The means of developing

Priority 3. Copy: The message.

between the lines) has remained constant to make as the original. The line feed (the amount of space I've had to reduce its size so that it fits the same area bold type of the body copy now takes more space Souvenir Light Italic to Souvenir Bold. Because the Italicto Souvenir Light and the main body copy from copy of the first paragraph from Souvenir Demi is now set in Serif Gothic. I've changed the body line, which was originally set in Serif Gothic Heavy, changing the weights of the typeface. The head-(right). I will repeat the design but this time weight and spacing can alter the design completely Now let us see how the wrong choice of type

read with comfort. will find that it is far too small in its bold style to be attention. When you look at the body copy you body copy competes with the illustration for longer has an initial impact and the strength of the the logical sequence of priorities, the headline no been a bit extreme, they do prove a point. Gone is While I'll admit that my modifications have the design as close to the original as possible.

TELLER SPACING

colour. will affect general readability more than tonal is influenced by the length of line, although this word spacing and line spacing. To a lesser extent it the typeface but also by its letter spacing, inter-Tonal colour is affected not only by the weight of

First let us look at letter spacing. As you would

at all of close spacing and individual kerning (the metal setting, in which there were no possibilities moved into the computer age out of the era of hor between individual characters. Now that we have expect, the term refers to the amount of space

standard letter spacing. example is set in 12/13pt Caxton Light with spacing, legibility is improved or decreased. This I will now show you how, by varying the letter

NOT make good typography. fashion at the expense of legibility, do too open, designed for the sake of understood. Letters that are too close or messages have to be read and and done, we are communicators. Our must remember that, when all is said from the set width. But all designers done by adding, or subtracting, units varying the standard spacing. This is colour of your body copy subtly by means that you can alter the tonal 1950s. This control over letter spacing style of typography reminiscent of the designers opting for an extremely open opposite direction, with many however, the movement is in the soon became fashionable. Now, spacing, particularly for headlines, were recognized, very tight letter of its infinitely flexible letter spacing setting first arrived and the advantages spacing, when computer-generated design, and in particular, to letter applies very much to typographical Fashions come and go. This certainly

12/13pt Caxton Light (standard letter spacing)

By adjusting letter spacing we can improve studios today can adapt their own 'house style'. spacing. This has meant that many agencies and Ye, etc.), we have total control over all forms of closing up of bad letter combinations such as To,

legibility appropriate to the particular Job.

Set-size

to the em. characters (including spaces) is calculated, which in turn relates directly of setting letters. The unit is the means by which the width of individual To understand letter spacing it is important to understand the principles

a 36pt square, etc. equivalent of 12 pts.) Therefore a 24pt em is a 24pt square, a 36pt em 1s particular point size. (It is not to be confused with pica em, which is the The em is a typographic measurement equal to the square of its

12pt, 36pt or 48pt. system, a single unit will represent 1/54 of the type size, whether it is that the unit is a proportional measurement. For example, with a 54 unit producing the greatest number of units per em. It must be appreciated 48, 54, and 64 are all common, with the latest typesetting machines The number of units per em varies from system to system, but 18, 32, 36, By dividing the em into equal vertical segments you arrive at the unit.

variations in letter spacing can be achieved, either by collective or by adding to, or subtracting from, the set width of the characters that and the differences between medium, condensed and expanded, etc. It is to typeface, to take into account the variations within the various faces The set width of a particular character will obviously vary from typeface of the character to prevent characters from touching when they are set. set-width or set-size, and includes a small amount of space to either side number of units. This dimension is referred to as the character's The way the system works is that each character is allocated a certain

individual adjustment.

The previous style works well and is popular for advertising setting, especially with settif typefaces. It does not always work so well with condensed sans setif faces because the vertical stress becomes too strong, as the following short paragraph illustrates. It is set in Univers Medium Condensed, -1.

wake good typography. TUN ob ,\tilidigal fo expense of legibility, do NUT close or too open, designed for the sake of read and understood. Letters that are too are communicators. Our messages have to be remember that, when all is said and done, we from the set width. But all designers must This is done by adding, or subtracting, units copy subtly by varying the standard spacing. you can alter the tonal colour of your body This control over letter spacing means that style of typography reminiscent of the 1950s. many designers opting for an extremely open movement is in the opposite direction, with became fashionable. Now, however, the spacing, particularly for headlines, soon spacing were recognized, very tight letter advantages of its infinitely flexible letter generated setting first arrived and the particular, to letter spacing. When computervery much to typographical design, and in Fashions come and go. This certainly applies

12/13pt Univers Medium Condensed (-1 letter spacing)

I will now repeat the previous passage, but this time reducing the set width from its standard setting to -1 of the standard.

NOT make good typography. tashion at the expense of legibility, do too open, designed for the sake of understood. Letters that are too close or Our messages have to be read and is said and done, we are communicators. designers must remember that, when all units from the set width. But all This is done by adding, or subtracting, subtly by varying the standard spacing. alter the tonal colour of your body copy over letter spacing means that you can reminiscent of the 1950s. This control extremely open style of typography with many designers opting for an movement is in the opposite direction, fashionable. Now, however, the particularly for headlines, soon became recognized, very tight letter spacing, of its infinitely flexible letter spacing were setting first arrived and the advantages spacing. When computer-generated design, and in particular, to letter applies very much to typographical Fashions come and go. This certainly

12/13pt Caxton Light (-1 letter spacing)

example represents +1 spacing. the setting scale and increase the set width. This We can, on the other hand, move the other way on

good typography. expense of legibility, do NOT make designed for the sake of tashion at the that are too close or too open, to be read and understood. Letters communicators. Our messages have when all is said and done, we are designers must remember that, units from the set width. But all is done by adding, or subtracting, by varying the standard spacing. This tonal colour of your body copy subtly spacing means that you can alter the of the 1950s. This control over letter open style of typography reminiscent designers opting for an extremely the opposite direction, with many Now, however, the movement is in headlines, soon became fashionable. letter spacing, particularly for spacing were recognized, very tight tages of its infinitely flexible letter setting first arrived and the advanspacing. When computer-generated design, and in particular, to letter applies very much to typographical Fashions come and go. This certainly

rather unpleasant style of setting. individual characters are now 'kissing', creating a sacrificed. The set width is now reduced to -5. The pens when space is over-reduced and legibility compare it with this piece, which shows what hap-Now look back to the example in Caxton Light and

of legibility, do NOT make good typography. designed for the sake of lashion at the expense stood. Letters that are too dose or too open, cators. Our messages have to be read and underwhen all is said and done, we are communiwidth. But all designers must remember that, ses and mort stimu gambendus to gailbbe varying the standard spacing. This is done by tonal colour of your body copy subity by letter spading means that you can alter the reminiscent of the 1950s. This control over an extremely open style of typographyy direction, with many designers opting for however, the movement is in the opposite for headlines, soon became tashionable. Now, Virelucitied, very light letter spacing, particularly tages of its infinitely flexible letter spacing were generated setting first arrived and the advanin particular, to letter spacing. When computerpure 'usissop jeonydersoda'i oj upnim Aran Fashions come and go. This certainly applies

12/13pt Caxton Light (-5 letter spacing)

12/13pt Caxton Light (+1 letter spacing)

greater degree of legibility is achieved. When I open up the line spacing to 12/16pt, a

typography. legibility, do NOT make good fashion at the expense of open, designed for the sake of Letters that are too close or too have to be read and understood. communicators. Our messages when all is said and done, we are designers must remember that, from the set width. But all adding, or subtracting, units standard spacing. This is done by body copy subtly by varying the can alter the tonal colour of your letter spacing means that you of the 1950s. This control over style of typography reminiscent opting for an extremely open direction, with many designers movement is in the opposite fashionable. Now, however, the headlines, soon became spacing, particularly for recognized, very tight letter flexible letter spacing were advantages of its infinitely setting first arrived and the When computer-generated particular, to letter spacing. typographical design, and in certainly applies very much to Fashions come and go. This

pared to the closeness of the line spacing. because of the openness of the letter spacing comunpleasant effect. This example does not read well +5, for example, as shown below, creates an spacing, it can be overdone. Setting the letters to Extra spacing can work well but, as with reduced

typography. legibility, do NOT make good tashion at the expense of open, designed for the sake of Letters that are too close or too have to be read and understood. communicators. Our messages when all is said and done, we are designers must remember that, from the set width. But all adding, or subtracting, units standard spacing. This is done by cody subtly by varying the the tonal colour of your body spacing means that you can alter 1950s. This control over letter typography reminiscent of the extremely open style of many designers opting for an in the opposite direction, with Now, however, the movement is lines, soon became fashionable. spacing, particularly for headrecognized, very tight letter flexible letter spacing were advantages of its infinitely setting first arrived and the When computer-generated particular, to letter spacing. typographical design, and in certainly applies very much to Fashions come and go. This

12/13pt Caxton Light (+5 letter spacing)

MORDSBYCING

with care it can provide your work with just the much or too little space can affect legibility. Used

amount of tonal variation that you are seeking. Word spacing can also be controlled, but again too

word space represents 2/3 the width of the lower spacing. I find that, as a general guide, the ideal small type sizes read better with a little extra word require less space than expanded faces do, and by the style of typeface chosen. Condensed faces As you would expect, word spacing is affected

character and for calculating overall width and machines for measuring the width of each type The unit system is used on computer typesetting case 'o', but this is only a starting point.

accomplish, design-wise, than the sans-sent typefaces. The latter almost require the skill at geometry of an architect.

spaces between the sent typefaces are more graceful and easier to

the letter, the more important the negative space. The negative

etters. The same holds true for the thinner weights. The larger

letters. This means more than just putting letters next to each other. Capital letters are more difficult to do than the lowerease

ood designers and rypographers gain, over the years, experience

rsual weight around the letter, in order to be balanced and pleas

etters. The negative space must be given some uniformity of

or by doing so mechanically. This creates irregular space between

Jabove. This is called the negative space. But good negative space

Took at the space in, and around, and in between the letters

In knowing how much negative space to put between each two

ng to the cye.

should be a good relationship between the upper and lowerease Each letter must have its uniqueness, but not be too expressive, so as to overpower the other letters in the alphabet. There spend hours creating masterpieces out of letters of the alphabet. Today's great type designers are masters at what they do. They

One well-known designer and art director in the New York City well as between them. capture harmonious whites (negative space) inside the letters, as characters as well. The type designer is also concerned with the balance of the black positive areas of each letter, and how to

Co, when taking all of the above into consideration, the creative prerson can enhance the beauty of the typeface design by the proper use of the negative space. The result? Typographical the positive areas. area always looks at the negative space first, before looking at

:soooidao;seu

allocated. Note how each character is allocated

48pt. The diagram illustrates how the divisions are

apply whether the size were to be in 10pt, 24pt or

54 units. This allocation of 54 unit divisions would ie. a capital M in Times Roman could be allocated

face does not affect the number of allocated units,

the width of each character. The size of the typeallocated to a given number of units which decide

the em is not uncommon. Each character will be system typesetting, but the division of 54 units to

units. These can vary from typesetting system to

em. Each em is divided into a given number of

of any given size of type, commonly known as the

counting. It's a simple system based on the square

HORITY PR. HELLICUTE WEST TO CHILLES, CHILLES MEST TO CHILLES, AND OPEN CHITES each letter to get the proper negative space. (The combinations however, that all other letters in that word are to have the same amount of space between them as the examples above. But one has to take into consideration the space inside and around can be spaced out visually to please the eye. This does not mean, Locgairve spaces. For example, L.A. T.T. IT, T.Y. L.L., L.B., and the like. They can be overlapped slightly, or altered, to cut down on the negative space between letters, and the rest of the word gain, there are certain letter combinations with unavoidably large other letters in the word. allow enough space in such combinations to complement the

cially when setting sans-sent typefaces. The trained eye will

IM, IV, II, etc. These are often put too close together, espe-

crtical stroke. This includes such combinations as AW, AV, Certain fundamental principles should be taken into consideration that have almost no space at all between them. Vertical stroke against have almost no space at all between them. Vertical stroke against

(STREETLAN OF TACKE)

44 TYPE: Making it work for you

awkward character combinations. white space between the toncy, thus avoiding too much allowed certain characters to It is a very tight style that has character spacing of the headline. points. Notice too the interwithin the text to illustrate specific with his use of bold and italic depth is a nice touch, together each paragraph over a two-line 17C Galliard. The hung initials for typetace, used to good effect, is Robert Wakeman. The principal of typography by New Yorker, Right A self-promotional piece

stinu 8 f

additional spacing both to its left and right. This presents the individual characters from touching during the setting process. It is possible to reduce or increase the spacing between the various characters either collectively or individually (a process known as kerning) by programming the computer to either reduce or increase the number of set units allocated to each individual character.

Here are a few examples. The following text has been set with standard word spacing, ranged left, in 10/11pt *ITC New Baskerville*.

Too much or too little space between words can seriously affect legibility. Too little space can cause the individual words to merge as one, creating difficulties for the reader in distinguishing one word from another; too much space can cause rivers that disrupt the natural movement of the eye from left to right. Rivers are a common problem within narrow measure justification.

Now here is the same example, but with tight word spacing:

Too much or too little space between words can seriously affect legibility. Too little space can cause the individual words to merge as one, creating difficulties for the reader in distinguishing one word from another; too much space can cause rivers that disrupt the natural movement of the eye from left to right. Rivers are a common problem within narrow measure justification.

And this time the example has been given very open word spacing:

Too much or too little space between words can seriously affect legibility. Too little space can cause the individual words to merge as one, creating difficulties for the reader in distinguishing one word from another; too much space can cause rivers that disrupt the natural movement of the eye from left to right. Rivers are a common problem within narrow measure justification.

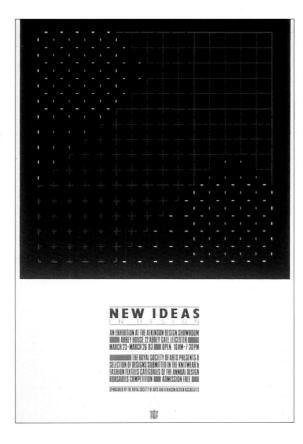

Left It isn't only body copy that can create grey tones, the same effects can be achieved by spacing condensed caps closely, as this poster for 'New ideas for design' clearly illustrates. I like the way the red blocks of colour have been used as a means of giving the text full justification without exaggerated word spacing. The design was by Grundy & Northedge.

This next example (1) is justified within a fairly narrow measure. This is when the problems of excessive rivers occur. It is a typical problem experienced with newspaper typography. ('River' is the term given to large areas of white space that run down through the text, caused by excessive word spacing.)

While the legibility of this example is the norm in newsprint, it is totally unacceptable for work that requires quality setting. But how do you improve the word spacing within the restrictions of the justified, narrow measure? The obvious answer is hyphenation. By the introduction of just three hyphens you can create an entirely new feel in the paragraph. Note how the hyphens are hung

Too little

the

one

that

for

rivers

Rivers are a common

problem within narrow

measure justification.

in the margin, in the example below (2). Although they go beyond the measure, the effect of the hung punctuation creates a more even righthand edge. In the previous example the punctuation was set within the measure. Although this example is considerably improved by the addition of hyphenation, there are still one or two lines that contain excessive word spacing.

This unsatisfactory visual problem can by improved by the introduction of semi-justification (3). This style is popular with advertising agencies. It requires all lines that fall beyond a predetermined point within the measure to be justified, whereas those that fall naturally short of the specified point fall unjustified.

- he has taken the unusual step of setting the entire text in caps with bold numerals in the appropriate 1 Too much or too little space between words measure. If you look carefully at the hung punctuation you will see can seriously affect that there are subtle variations in legibility. their positions depending upon space can cause the individual words to example, the hyphen following the merge as one, creating T in ADJUST is kerned up to the stem of the T, whereas the next difficulties hypen, in the line below, hangs reader out further. This is quite legitimate distinguishing because the overall optical effect word from another; too much space can cause disrupt the natural movement of the eve from left to right.
- Too much or too little space between words can seriously affect legibility. Too little space can cause the individual words to merge as one, creating difficulties for the reader in distinguishing one word from another; too much space can cause rivers that disrupt the natural movement of the eye from left to right. Rivers are a problem common within narrow measure justification.
- Too much or too little space between words can seriously affect the legibility. Too little space can cause the individual words to merge as one, creating difficulties for the reader in distinguishing one word from another; too much space can cause rivers that disrupt the natural movement of the eye from left to right. Rivers are a common problem within narrow measure justification.

Opposite right The reworked design is a good example of Cogent left (semi-justified) style. It works best if the lines can alternate between long and short, long and short. This example also includes hung punctuation.

Opposite far right Another creative piece of typography from

Robert Wakeman. In this example

positions over a long, narrow

the previous character. For

is of two perfectly aligned

columns

Too much or too little space between words can seriously affect legibility. Too little space can cause the individual words to merge as one, creating difficulties for the reader in distinguishing one word from another; too much space can cause rivers that disrupt the natural movement of the eye from left to right. Rivers are a common problem within narrow measure justification.

Semi-justification was devised by two British typographers, David Kelsey and Ed Everley, when they were working for an advertising agency called Cogent Elliott. They therefore named their new system Cogent left. Now slightly modified, the system is still often called Cogent left in Britain, although the term semi-justification is becoming widely used there, as well as in the U.S.

You saw in the first example how short line lengths could create excessive word spacing and consequently affect legibility. Extra long measures can also hinder readability and understanding. The ideal number of characters per line for body copy is around the 36 to 50 mark. When the number of characters goes well beyond that point, to 80 and above, readability suffers considerably.

At The Villages of Fernbrook, lunch with the family can be a real picnic.

Our lifestyle just naturally seems to bring families closer together. The picnic area is a great place for family fun. The kids will love playing in the shade of tall trees and exploring wooded trails. There's even a pond for romantic strolls, skipping stones or just daydreaming.

So come visit our two, three and four bedroom colonial-style homes today. The Villages of Fernbrook include Chatham Grove, Taylor's Landing I and II, Olde Williamsburg and Old Fernbrook. There's even special financing available that makes these homes very affordable.

You'll find plenty of room for growing families and you'll discover life here can be a real picnic.

Models open from 1 p.m. til dusk. Go west 3 miles on Rt. 360 from Chippenham, left on Fordham Rd. Follow the signs.

WHY ITTAKES TYPESETTING OPERATIONS TO INSERT JUST ONE LITTLE

WORD OF COPY IN YOUR AD 1. THE CHANGE IS PHONED IN 2. IT'S ENTERED ON A TIME SHEET AND JOB TICKET. - 3. THEN IT'S SENT TO THE COMPOS-ING ROOM. * 4. THE OPERATOR INTERRUPTS THE JOB ON WHICH HE'S WORKING. * 5. HE MAKES A VARIETY OF MACHINE ADJUST MENTS AND BRINGS THE ORIG-INAL SETTING UP ONTO THE SCREEN. -> 6. HE INSERTS THE NEW WORD INTO THE PARA-GRAPH AND SETS A SLUG LINE FOR IDENTIFICATION. & 7. THE CORRECTED COPY IS THEN RUN OUT. * 8. THE EXPOSED FILM IS DEVELOPED, FIXED, WASHED, AND DRIED IN A SEPARATE AU TOMATIC PROCESSOR. 39. THE CORRECTED COPY IS THEN SENT TO A STRIPPER, WHO MUST LOCATE THE ORIGINAL FILM MECHANICAL TO BE ADJUSTED - 10. HE FINDS THE FILM MECHANICAL AND PLACES IT ON HIS LIGHT TABLE, INSERTS THE CORRECTION AND SENDS THE FORM TO THE PROOFING DEPARTMENT. * 11. THE FILM IS PROOFED ONCE, AND THEN SENT TO A READER TO CHECK THE CORRECTNESS OF THE NEW COPY. 🚈 12. THEN BACK TO THE PROOFING DEPARTMENT WHERE THE CORRECT NUMBER OF REVISED PROOFS ARE PULLED. 313. THE FILM ME-CHANICAL IS RETURNED TO ITS ORIGINAL AND CORRECT LOCA-TION IN STORAGE. 🙇 14. TIME RECORDS FOR BILLING PUR-POSES ARE ENTERED. M 15. THE REVISED PROOFS ARE SENT BY MESSENGER TO THE AGENCY.

LINESPACING

Despite the importance of letter and word spacing, the biggest single factor that will affect the tonal grey of the body copy is line spacing. Light type can look strong and medium copy weak just by a varia-

Just as word and letter spacing affect the tonal greys of your body copy, so will the space between each line affect its legibility and tonal colour. The choice of typeface, type size, and line length are other factors to consider, but line spacing decisions are usually made around the correct tonal colour for the design problem rather than being restricted by the norm for the chosen typeface.

-1pt line feed (9/8pt)

Just as word and letter spacing affect the tonal greys of your body copy, so will the space between each line affect its legibility and tonal colour. The choice of typeface, type size, and line length are other factors to consider, but line spacing decisions are usually made around the correct tonal colour for the design problem rather than being restricted by the norm for the chosen typeface.

+1pt line feed (9/10pt)

Just as word and letter spacing affect the tonal greys of your body copy, so will the space between each line affect its legibility and tonal colour. The choice of typeface, type size, and line length are other factors to consider, but line spacing decisions are usually made around the correct tonal colour for the design problem rather than being restricted by the norm for the chosen typeface.

+3pt line feed (9/12pt)

tion of the line feed. These next examples alter the value of the copy as they progress from -1pt line feed through to +4pt line feed. The examples are set in 9pt Parlament Roman.

Just as word and letter spacing affect the tonal greys of your body copy, so will the space between each line affect its legibility and tonal colour. The choice of typeface, type size, and line length are other factors to consider, but line spacing decisions are usually made around the correct tonal colour for the design problem rather than being restricted by the norm for the chosen typeface.

set solid (9/9pt)

Just as word and letter spacing affect the tonal greys of your body copy, so will the space between each line affect its legibility and tonal colour. The choice of typeface, type size, and line length are other factors to consider, but line spacing decisions are usually made around the correct tonal colour for the design problem rather than being restricted by the norm for the chosen typeface.

+2pt line feed (9/11pt)

Just as word and letter spacing affect the tonal greys of your body copy, so will the space between each line affect its legibility and tonal colour. The choice of typeface, type size, and line length are other factors to consider, but line spacing decisions are usually made around the correct tonal colour for the design problem rather than being restricted by the norm for the chosen typeface.

+4pt line feed (9/13pt)

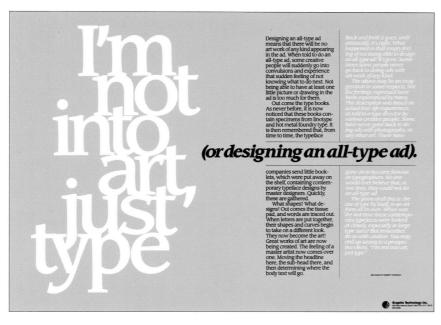

of glass which, when we came down on it with molten glass, would fuse and mold together as it was blown out. I began a series of cylinders to further explore the idea of drawing into glass. I go back to the series now and carrying on the Venetian then because the process is still unpredictable and continues to stimulate me.

Society and thought I would try blowing some very thin basketlike forms People would rather drive crumpling and collapsing I didn't want them symmetrical. It was quite could do with just air, fire and gravity using hardly any tools. In the summer of 1977, I made about 100 baskets, all the same color (tabak), and they were shown on a steel table at

'At one point, I went to Murano to study. Strange, I and others are still

The last few years I've tradition. They're losing been a kind of nomad. working with my traveling it over there because of modern technology. There team in many different doesn't seem to be the universities and shops desire for handmade around the United States and in Europe. glasses when glasses made by machines are "When I'm not traveling available at less cost. for my work, I'm often

a Porsche, which is made traveling for pleasure. by machine, than a more Every year or two, I visit expensive Rolls-Royce. some unusual archipelago which is primarily made of islands - most recently the Orkneys and the Scilly "We start blowing at Islands off Great Britain and the coast of Brittany. through with no breaks. I love islands. I'm The blowing just seems to fascinated by the fact that, go better on the early being isolated, they schedule. It's quieter and develop uniquely." the shop is cooler and the glass is at its best in

the morning, I don't know why. And we have more

privacy. We then stop for a

big lunch - lots of Italian

style. This has a pull on my social life. Maybe that's why I never got married.

These three examples all have one thing in common, text which has been ranged on one edge and set ragged on the other. There are subtle variations. however. Above left The example by Robert Wakeman, with its subheading running through the text, uses discretionary hyphenation to prevent lines of too short a measure. Above This piece is not primarily text setting, but is a good design example of headlines and subheads set ranged left. Left The designers, Bennett Robinson and Paula Zographos, have avoided both hyphenation and lines of short measure, probably by means of intelligent copy editing.

CHANGING YOUR FACE

Ultimately, tonal greys are determined by the typeface you use. Look at the comparison of different typefaces using the same copy (shown on these pages). All are set to the same measure (16½ ems) 70mm, size and line feed (10/11 pt) 2.5mm cap height 4.13mm line feed and depth (11 lines), and yet the tonal greys are quite different.

Century Schoolbook

Excellence in typography is the result of not hing more than an attitude. Its appeal come s from the understanding used in its plannin g; the designer must care. In contemporary a dvertising the perfect integration of design e lements often demands unorthodox typography. It may require the use of compact spacing, minus line feed, unusual sizes and weights; whatever is needed to improve appearance and impact. Stating specific principles or guides on the subject of typography is diffic

Fenice Bold

Excellence in typography is the result of not hing more than an attitude. Its appeal come s from the understanding used in its plannin g; the designer must care. In contemporary advertising the perfect integration of desig n elements often demands unorthodox typo graphy. It may require the use of compact sp acing, minus line feed, unusual sizes and weights; whatever is needed to improve appe arance and impact. Stating specific princip les or guides on the subject of typography is

Gill Sans Extra Bold

Excellence in typography is the result of nothing more than an attitude. It s appeal comes from the understanding used in its planning; the designer must care. In contemporary advertising the perfect integration of design elements often demands unorthodo x typography. It may require the use of compact spacing, minus line feed, unusual sizes and weights; whatever is needed to improve appearance and impact. Stating specific principles o

Goudy Old Style Roman

Excellence in typography is the result of nothing more than an attitude. Its appeal comes from the u nderstanding used in its planning; the designer mu st care. In contemporary advertising the perfect int egration of design elements often demands unorth odox typography. It may require the use of compact spacing, minus line feed, unusual sizes and weigh ts; whatever is needed to improve appearance and impact. Stating specific principles or guides on the subject of typography is difficult because the principle applying to one job may not fit the next. N

Medieval Italic

Excellence in typography is the result of nothing more than an attitude. Its appeal comes from the understanding used in its planning; the designer must care. In contemporary advertising the perfect integration of design elements often demands unorthodox typography. It may require the use of compact spacing, minus leading, unusual sizes and weights; whatever is needed to improve appearance and impact. Stating specific principles or guides on the subject of typography is difficult because the principle applying to one job may not fit the

Rockwell Roman

Excellence in typography is the result of nothing more than an attitude. Its appeal comes from the understanding used in its planning; the designer must care. In contemporary advertising the perfect integration of design elements often demands unorthodox typography. It may require the use of compact spacing, minus line feed, unusual sizes and weights; whatever is needed to improve appearance and impact. Stating specific principles or guides on the subject of typography is difficult because the

Univers 45 Light

Excellence in typography is the result of nothin g more than an attitude. Its appeal comes fro m the understanding used in its planning; the designer must care. In contemporary adverti sing the perfect integration of design elements often demands unorthodox typography. It may require the use of compact spacing, minus line feed, unusual sizes and weights; whatever is needed to improve appearance and impact. Stating specific principles or guides on the subject of typography is difficult because the prin

Left This example by typographer Robert Wakeman is similar in style to his previous designs, set ranged left and ragged right and with much the same use of discretionary hyphenation. The headline spacing is tight, and again he's not afraid to allow certain characters to 'kiss'. This example illustrates very well the pleasing use of hanging indentation as an alternative style to standard paragraph indentation. The typefaces used are ITC Novarese bold italic and ITC Berkeley Old Style.

Below This is a wonderful example of the marriage between photography, design, typography and white space. Simha Fordsham, Jonas Tse and Nancy Leung of Olympia & York Developments Ltd all had a hand in this design for 425 Lexington Avenue, New York. The prominent typographical feature is the ultracondensed cap A (in Empire) which covers a depth of eight lines into the Century Old Style body type. It breaks up what could otherwise have been an ordinary block of text.

VARIATION FOR EMPHASIS

All the previous examples are ways in which the designer can create tonal variety and impact with the body copy. But there are many occasions, especially in advertising, when tonal variety is needed to lay a particular emphasis or accent. This emphasis is created easily by the intelligent inclusion of italics, capital letters, underscoring, additional faces from the chosen type family, or other contrasting typefaces compatible with the main body copy.

When deciding which words, phrases, etc. need to stand out, and to what degree, remember that too much emphasis can have the opposite effect to the one you want. Overlong phrases can lose their punch if the reader loses track of where the extra stress is intended. The amount of copy and where it occurs within the main body of text will also influence its emphasis. A single word in the middle of a large section of body copy can easily be lost with the wrong treatment, and will need to be highlighted differently from a word which is emphasized at the beginning of a paragraph.

The use of *italic* is a simple method of drawing attention to a single word or short phrase. It is an easy way to highlight the occasional word without altering the tonal colour of the body copy.

If the copy requires some extra emphasis it can be achieved by the introduction of CAPITAL LET-TERS, but they can sometimes alter balance and readability if a phrase or sentence is too long to be taken in at one glance.

On the other hand the introduction of SMALL CAPS can offer a different alternative to the more aggressive full-sized capital. Their use is ideal for letterheads in which directors have lengthy QUALIF-

style, always try to make the first line of each paragraph shorter than the following one, as it is here. Also be aware of the shape your copy makes, and don't be afraid to alter line endings to improve the overall design.

Below This example of a

ICATIONS. When ordering SMALL CAPS make sure that your typesetter has a true, small caps font and doesn't try to get away with a smaller point size of your chosen typeface. There is a difference.

Probably the most common method of emphasizing text is by increasing the weight of your typeface, from light to medium, or medium to bold. It attracts attention and is hard to ignore. Unlike italic, caps and small caps, it will have a greater effect upon the tonal balance of your layout. This is usually the very reason for using the heavier weight of type.

The introduction of a different typeface within the body copy to make a point needs far more control. The reason for the change has to be sound. Unless it is used for subheadings, titles, or captions, it rarely works. Where it does work, and with very good effect, is in magazines and illustrated books. There are other means of creating colour variation within your designs and we'll look at these as we progress through the book.

Below This example of a letterhead may be fashionable now, but I wonder how long this style will last. It is very important for designers to be conversant with current trends and fashions. but the trouble with fashions is that is just what they are - a fashion one minute, out-of-date the next. If your design is for now and is soon to be replaced as the next season, brand, etc. comes along, that is fine, but when you are designing for more lasting items, such as corporate identities and letterheads, a more lasting quality is required.

Left This double-page spread, with typography by Wendy Harrop, is just as fine in its use of white space as the example on the opposite page. The use of centred body copy is a change in style from the conventional ranged left or justified text. When using this

Right This design, by Robert Wakeman, is a very good example of type variation and how it can create tonal contrast. He has combined italic and bold italic, using the bold for the first line of each-paragraph, and has then reversed this image with bold and light Roman, using the light face to start each paragraph. It is not immediately obvious but he has also varied the weights of his headline. Each line was set in the same face but in a different weight and size. The boxed headline shows what it would have looked like if the three weights were set in the same size.

- Above left A very colourful double-page spread designed by Vásken Kalayjian of the Glazer Kalayjian Studio. With the main text set in Times Roman the use of coloured illustrations and simple run-arounds has created life and interest in this spread.
- Left A Pentagram UK design for the 'World' magazine. Work of this nature often has the restrictions of just one- or two-colour printings. This is one such piece. A great deal of importance has been placed on the creative use of white space.
- Above A superb double-page spread from Pentagram UK. The typographic information is all there but in no way does it interfere with the beautiful photography. An excellent example of functional layout and typography, it contains no gimmicks, just sensible design.

Have any colour you like so long as it's black*'

Has the question ever occurred to you why so much magazine typography, particularly the headlines for advertising copy, appears in black only when the facilities for full colour typography are available? The reason can't be the extra cost, because the price of the colour separations will already have been met. The reason must therefore be one of readability.

BLACK ON WHITE VERSUS WHITE ON BLACK

Generally speaking, black type on white is extremely legible; conversely white type reversed out of black is not. White reversed out of black can be visually strong, but only if the right face is used. For example, a fine serif face below 12pt for large areas of text is not a good idea because the words will not be clear. Also, the quality of platemaking, and particularly the inking of the press rollers, must be perfect because there is a strong tendency for the serifs to fill in. If the typeface contains fine hairline strokes, these too can be lost.

Studies have been made concerning the clarity of white type reversed out of black — with startling results. These results showed that for large areas of text, readability was reduced by some 50 percent. The main reason for this is that our eyes suffer strain when we read through large areas of reversed-out type. The degree of reduced comprehension will increase still further if the print quality is poor. Also, when white type is reversed out of a four-colour background, as opposed to just

black, further problems will occur if the registration is not perfect. This often occurs with mass-produced magazine work and newsprint in full-colour.

These findings should affect your approach to typography and colour, because if the visual effect of white out of black, or any other colour for that matter, jeopardizes the understanding of the message and the information, then it is not good design.

Sometimes white type is essential to fulfil a particular design requirement. The most successful faces come from the stronger moderns, such as *Souvenir, Congress* and *Bookman*. These faces have little contrast between their thick and thin strokes, and have strong serifs which are less likely to suffer from poor platemaking, registration or printing. Medium or semi-bold sans serifs can also be considered, but their stronger vertical stress needs increased leading to counter it.

■ The following two pages illustrate different faces reversed out of black in two type sizes, 12/14pt and 6½/8½. Note how the smaller Rockwell reads better than the 12pt Fenice light. Always take extra care when attempting such effects.

^{*} Back in the thirties the Ford Motor Company ran a series of famous advertisements for their Model T Ford which said, 'You can have any colour you like so long as it's black.'

Rockwell Regular

to fill in.

Generally speaking, black on white type is extremely legible; conversely white type reversed out of black is not. White reversed out of black can be visually strong, but only if the right face is used. For example, a fine serif face below 12pt for large areas of text is not a good idea because the words will not be clear. Also, the quality of platemaking, and particularly the inking of the press rollers, must be perfect since

there is a strong tendency for the serifs

Rockwell Regular

Generally speaking, black on white type is extremely legible; conversely white type reversed out of black is not. White reversed out of black can be visually strong, but only if the right face is used. For example, a fine serif face below 12pt for large areas of text is not a good idea because the words will not be clear. Also, the quality of platemaking, and particularly the inking of the press rollers, must be perfect since there is a strong tendency for the serifs to fill in. If the typeface contains fine hairline strokes, these too can be lost.

Gill Sans

Generally speaking, black on white type is extremely legible; conversely white type reversed out of black is not. White reversed out of black can be visually strong, but only if the right face is used. For example, a fine serif face below 12pt for large areas of text is not a good idea because the words will not be clear. Also, the quality of platemaking, and particularly the inking of the press rollers, must be perfect since there is a strong tendency for the serifs to fill in. If the typeface contains fine hairline strokes, these too can be lost.

Fenice Light

Generally speaking, black on white type is extremely legible; conversely white type reversed out of black is not. White reversed out of black can be visually strong, but only if the right face is used. For example, a fine serif face below 12pt for large areas of text is not a good idea because the words will not be clear. Also, the quality of platemaking, and particularly the inking of the press rollers, must be perfect since there is a strong tendency for the serifs to fill in. If the typeface contains fine hairline strokes, these too can be lost.

Gill Sans

Generally speaking, black on white type is extremely legible; conversely white type reversed out of black is not. White reversed out of black can be visually strong, but only if the right face is used. For example, a fine serif face below 12pt for large areas of text is not a good idea because the words will not be clear. Also, the quality of platemaking, and particularly the inking of the press rollers, must be perfect since there is a strong tendency for the serifs to fill in. If the typeface contains fine hairline strokes, these too can be lost.

Fenice Light

Generally speaking, black on white type is extremely legible: conversely white type reversed out of black is not. White reversed out of black can be visually strong, but only if the right face is used. For example, a fine serif face below 12pt for large areas of text is not a good idea because the words will not be clear. Also, the quality of platemaking, and particularly the inking of the press rollers, must be perfect since there is a strong tendency for the serifs to fill in. If the typeface contains fine hairline strokes, these too can be lost.

Souveni

Generally speaking, black on white type is extremely legible; conversely white type reversed out of black is not. White reversed out of black can be visually strong, but only if the right face is used. For example, a fine serif face below 12pt for large areas of text is not a good idea because the words will not be clear. Also, the quality of platemaking, and particularly the inking of the press rollers, must be perfect since there is a strong tendency for the serifs to fill in.

Bookman

Generally speaking, black on white type is extremely legible; conversely white type reversed out of black is not. White reversed out of black can be visually strong, but only if the right face is used. For example, a fine serif face below 12pt for large areas of text is not a good idea because the words will not be clear. Also, the quality of platemaking, and particularly the inking of the press rollers, must be perfect since there is a strong tendency for the serifs to fill in.

Souvenir

Generally speaking, black on white type is extremely legible; conversely white type reversed out of black is not. White reversed out of black can be visually strong, but only if the right face is used. For example, a fine serif face below 12pt for large areas of text is not a good idea because the words will not be clear. Also, the quality of platemaking, and particularly the inking of the press rollers, must be perfect since there is a strong tendency for the serifs to fill in.

Bookman

Generally speaking, black on white type is extremely legible; conversely white type reversed out of black is not. White reversed out of black can be visually strong, but only if the right face is used. For example, a fine serif face below 12pt for large areas of text is not a good idea because the words will not be clear. Also, the quality of platemaking, and particularly the inking of the press rollers, must be perfect since there is a strong tendency for the serifs to fill in.

Congress

Generally speaking, black on white type is extremely legible; conversely white type reversed out of black is not. White reversed out of black can be visually strong, but only if the right face is used. For example, a fine serif face below 12pt for large areas of text is not a good idea because the words will not be clear. Also, the quality of platemaking, and particularly the inking of the press rollers, must be perfect since there is a strong tendency for the serifs to fill in.

Congress

Generally speaking, black on white type is extremely legible; conversely white type reversed out of black is not. White reversed out of black can be visually strong, but only if the right face is used. For example, a fine serif face below 12pt for large areas of text is not a good idea because the words will not be clear. Also, the quality of platemaking, and particularly the inking of the press rollers, must be perfect since there is a strong tendency for the serifs to fill in.

INTRODUCING COLOUR

legibility suffers further. and, again, if the registration is fractionally out, below) is not good design; the edges lack clarity tone process. The screening of fine type (14pt and colour has to obtained by the four-colour halfgeneral magazine production, where any fifth crisper image than could otherwise be achieved in ically for the copy. This ensures a far cleaner, material where a fifth colour can be used specifbut should really only be used in promotional The softer dark browns and greys can work well recessive nature it does not strain the eyes as much. the same is true of cyan, although because of its degree of reasonable legibility. To a lesser degree yellow on white is far too weak in tone for any violet colours are just as tiring on the eyes, while The bright magenta and secondary red, green and whether they are on white or reversed out of black. similar problems to white reversed out of black, Body copy set in the three primary colours creates

Cult fugitant untantque tuent sot enam caecat, contra si cendete pergas propretes quia uis magnast ipsius, et alte aera per purum quia graniter simulaera feruntur, et feriunt oculos turbantia composituras. Praetetra splendor quicumque est acet adurit oculos, ideo quod semina possidet ignis multa, dolorem oculis quae gignunt insinuando. Lurida praeterea fiumt quaecumque saepe tuentur.

Aquae gignunt insinuando. Lurida praeterea fiumt quaecumque saepe tuentur.

Ossidet ignis multa, dolorem oculis quae gignunt insinuando. Lurida praeterea funt quaecumque tuentur arquati, quia luroris de corpore eorum semina multa fluunt simulacris.

Fugitant uitantque tueri; sol etiam caecat, contra si tendere pergrant uitantque tueri; sol etiam caecat, contra si tendere pergrant uitantque tueri; sol etiam caecat, contra si tendere pergrant uitantque tueri; sol etiam caecat, contra si tendere pergrant uitantque tueri; sol etiam caecat, contra si tendere pergrant uitantque tueri; sol etiam caecat, contra si tendere pergrant uitantque tueri proprete duita uita magnast ipsius, et alte aera per purum pergrant uitantque tueri pergrant uitantq

pergas proprerea quia uis magnast ipsius, et alte aera per purum saepe grauiter simulaera feruntur, et feriunt oculos turbantia composituras. Praeterea splendor quicumque est acer adurit oculos, ideo quod semina possidet ignis multa, dolorem oculis quae gignunt insinuando.

Aquati, quia luroris de corpore corum semina multa fluunt simulacris. Culi fugitant uitantque tueri; sol etiam caecat, contra si tendere pergas propterea quia uis magnast ipsius, et alte aera per purum grauiter simulacra feruntur, et feriunt oculos turbantia composituras. Praeterea splendor quicumque est acer adurit saepe oculos, ideo quod semina.

Ossidet ignis multa, dolorem oculis quae gignunt contra insinuando. Lurida praeterea fiunt quaecumque tuentur arquati, luroris de corpore corum semina multa fluunt simulacris.

Left The three examples colours – magenta, cyan and colours – magenta, cyan and

would question the use of the reversed-out type in parallel blocks at the bothom. Reading type within vertical stripes is difficult enough without the reversal – but perhaps the copy isn't all that important.

■ Below | he headline of this striking two-colour poster by Airking two-colour poster by disnitegration of the characters doesn't affect legibility at all, in fact it draws the eye toward it, as the designer intended. However, I the designer intended. However, I

type could have been used in any colours other than black and white. There does seem to be rather too much to read esaily, but when seen as a full-size poster this is not a serious problem.

■ Above A very powerful poster designed by the company Lloyd Northover for the Royal two colours. With a concept such as this there is no way in which as this there is no way in which

■ Posters seem to lend themselves to reversing out. I like the way the Alvin Ailey design by Steff Geissbuhler **below** has created space with its openly spaced Bodoni. The example right shows how design can change by alternating colours.

Below right, a multi-coloured typeface designed by Pentagram UK breaks the rules of logic yet still works.

Coloring the native type to the set of the s

Rules are made to be broken, and limited use of coloured type can work, provided that the typeface is sufficiently strong for good readability and that the quantity of body copy is restricted before eye strain occurs. Obviously such thresholds can be assessed by the designer only in the context of the work in question.

Et alte aera per purum grauiter simulacra feruntur, et feriunt oculos turbantia composituras. Praeterea splendor quicumque est acer adurit saepe oculos, ideo quod semina possidet ignis multa, dolorem oculis quae gignunt insinuando.

Urida praeterea fiunt quaecumque tuentur arquati, quia luroris de corpore eorum semina multa fluunt simulacris. Spolendor quicumque est acer adurit saepe oculos, ideo quod. ■ Left Further examples of coloured type, this time against a white background demonstrates the legibility of colours.

Quia uis magnast ipsius, et alte aera per purum grauiter simulacra feruntur, et feriunt oculos turbantia composituras Praeterea splendor quicumque est acer adurit saepe oculos, ideo quod semina.

Ossidet ignis multa, dolorem oculis quae gignunt insinuando. Lurida praeterea fiunt quaecumque tuentur arquati, quia luroris de corpore eorum semina multa

■ Left This design really speaks for itself. Beautiful, evocative colour with limited copy, creates an image that is easy to read, and restful on the eyes.

Et alte aera per purum grauiter simulacra feruntur, et feriunt oculos turbantia composituras. Praeterea splendor quicumque est acer adurit saepe oculos, ideo quod semina possidet ignis multa, dolorem oculis quae gignunt quia insinuando.

Urida praeterea fiunt quaecumque tuentur arquati, luroris de corpore eorum semina multa fluunt simulacris. Spolendor quicumque est acer adurit saepe oculos, ideo quod.

■ Far left A page from a small booklet promoting an Albuquerque printer. The style throughout follows the format of pure colour with limited text, the purity being achieved by printing each colour separately. It is an expensive method but excellent printing does cost a lot. Left This coloured type has been tastefully handled by Grundy Northedge. Without the subtlety of the grey tint background the lettering could have looked rather raw and crude.

■ Two contrasting examples of coloured type. **Above** This piece contains limited type and restful colour which is easy on the eye. **Right** A vibrant and fiery example, but I wonder if anyone has managed to read any of the text?

TYPE ON TEXTURE

There are other instances where legibility suffers which don't refer merely to reversed-out type. The most common form of type misuse is the combination of text over illustrative material. Black type over a plain dark colour can read quite well, but black text over a heavily textured background, even if it's a light colour, can become virtually in-

decipherable. This is a very common fault, when type, particularly body copy, is combined with full-colour photography, and it explains why so many art directors play safe with their advertising layouts by using the standard format of squared-up half-tones with black text on white below the illustrative matter.

■ Right One of the most effective ways of printing type over a textured background is to use textured paper. This delightful ticket printed in just two flat colours is a fine example of how well this can work.

Cull ingrant analogue energ sol etiam caecat, contra si tendere purgas propteres que us tragnasi postas en alte aera per pur un granter operatora teranistico fermos ceulos turbarria comprisivaras. Practeres aplendos quienniquo escaper adurtes aco centos, also quod senina.

Black text on a light-coloured texture

Possidet ignis multa, dolorem oculis quae gignunt insinuando. Lurida praeterea fiunt quaecumque tuentur. Aquati, quia luroris de corpore eorum semina multa fluunt simulacris. Culi fugitant uitantque tueri; sol etiam caecat, contra si tendere pergas propterea quia uis

Black text on a dark, flat colour

Magnast ipsius, et alte aera per purum grauiter simulacra feruntur, et feriunt oculos turbantia composituras. Praeterea splendor quicumque est acer adurit saepe oculos, ideo quod semina. Ossidet ignis multa, dolorem oculis quae gignunt insinuando.

Black text on a dark texture

Left This endpaper design is for a booklet for the Mohawk Paper Mills' graphic essay on 'Mazes and Labyrinths.' Seymour Robins designed the typeface specially for the project. His intention was to create a display face which contained good classic qualities vet was modern and distinctive in its usage. He has now developed a complete alphabet under the name of 'Labyrinth-Logo.' Because the function of this design is purely decorative, it is quite acceptable to allow the typography itself to 'become' the texture.

■ Bottom left The masthead for the magazine Skald from Pentagram UK. The copy line below the main title is difficult to read over the texture, but such information normally contains minor text only and is not critical. Below In these two examples comprehension really does matter. My reaction to the first, which is reproduced same size, is: 'When will they learn? Why make reading difficult for people?' It's just poor design. The second example is a little better as the simpler tones of the background make reading easier, but it's far from perfect.

WHEN PAPER IS used as a support for watercolour, or acrylic paints heavily diluted with water, it is necessary to stretch it. Basically fibres of the paper are dampened and they expand. Held in this state as the water evaporates, the resulting strain ensures that even if the paper is subjected to a heavy application of watery paint, as in a wash, the paper remains flat and does not buckle or bubble. For some people the process is stunningly easy to understand and execute. For others it is a hit and miss activity with unpredictable

the finished article will lo will have been minimal ar buckle at the merest hint of

Water can be applied w quickly moving over one s other, creating a surface wl but does not have a pool of sitting on it. The paper car tap, but care needs to be papers. The use of a tray fi often recommended, but av

THERE ARE AN enormous number of papers and boards to choose from. Not all of these are intended for artistic use, but separating out those that are is not a simple matter. This is because the use of paper by artists, illustrators and designers is not confined to drawing and painting. Even if it were, there are different types of drawing and painting using different media, which require properties

have given us its name from papyrus, the reed they used to make scrolls. Several *Books of the Dead*, a sort of Michelin guide to the afterlife, can be seen on it at the British Museum. In very general terms it resembles paper, but there is no direct connection and it was the Chinese who actually invented it. Exactly when is a moot point. 200 to 300 years BC seems probable and some examples that can be dated to that

on ma Or diff pa the ing fro

BREAKING THE RULES

The question that now needs to be posed is: Do art directors have to play safe to create imaginative, lively layouts?'The answer is obviously 'No!'But how can the designer move away from the security of the standard style and avoid the pitfalls of badly executed white out of black type, or type over complex textured backgrounds?

Of course, the actual product to be promoted does have a bearing upon the approach to the design problem. For example, car advertising tends to lend itself to the squared-up half-tone approach where excellence of photography is a prerequisite. There are, however, countless areas of the visual

communications industry where a more imaginative approach can and should be employed.

First of all, let us study the headline *Be adventu-rous...Take chances'* — a suitable, short phrase for the purpose of these examples and a phrase that could be etched above the drawing boards of all creative designers (see below left). Conventionally the headline would be placed in one or two lines with close letter spacing in a strong serif face. And the colour? Black of course! (Notice the kerning, in particular the 'a' set under the arm of the 'T'.)

Although the phrase is short there is no reason why type mixing can't be employed. Variation can easily be introduced with extreme contrast of

"Be adventurous ... Take chances"

"BE ADVENTUROUS...
TAKE CHANCES"

Tuli fugitant uitantque tueri; sol etiam caecat, contra si tendere pergas propterea quia uis magnast ipsius, et alte aera per purum grauiter simulacra feruntur, et feriunt oculos turbantia composituras. Praeterea splendor quicumque est composituras especiales, ideo quod semina acer adurit saepe oculos, ideo quod semina possidet ignis multa, dolorem oculis quae gignunt possidet ignis multa, dolorem funt quaecumque insinuando. Lurida praeterea fiunt quaecumque

Italic with vertical alignment

uli fugitant uitantque tueri; sol etiam caecat, contra si tendere pergas propterea quia uis magnast ipsius, et alte aera per purum grauiter simulacra feruntur, et feriunt oculos turbantia composituras. Praeterea splendor quicumque est acer adurit saepe oculos, ideo quod semina possidet ignis multa, dolorem oculis quae gignunt insinuando. Lurida praeterea

Large initial character

weight. By moving away from the close spacing and introducing a sans serif face, you can achieve a totally different feel.

But why not introduce colour as well — not throughout, but a contrast of colour together with black and white? Roman mixed with italic will also introduce another new variation. As you can see from the examples, the extent of variation need be restricted only by the designer's own limitations of creativity.

The body copy can also be given a fresher appearance when it moves away from orthodox styles of setting. Black type on coloured tints, italic body copy with vertical alignment and various forms of large first character initials all create an unusual effect.

- Above An excelient poster in which the designer, Allen Wong of the Brown Design group, has cleverly integrated Caslon No 471 with Avant Garde Bold for the main title. In spite of the 50 percent difference in size between the two segments of each character, legibility does not suffer. It is another example of the tremendous flexibility that type allows the creative imagination. Below the title Frutiger light and bold is set on a 50 degree indent.
- Left This striking book jacket, designed by Crucial Books, is a good example of the use of vertical italic.

STYLE AND MARKET TARGET

The style of headline does of course have to be sympathetic towards the product, but that is no reason for reduced creativity. Not only is the product important but the socio-economic groupings of the projected market and the age of the potential consumer have also to be taken into account. Promotion for the teenage market can, as you would expect, be more aggressive. Blocks of different colours behind type, a complete mix of founts for every character, the introduction of script capitals together with sans serif characters,

italic founts with the stem aligned vertically allowing the type to run uphill — all are possibilities and can be successfully mixed when appealing to the younger generation. These same techniques can be applied to an older, more mature market, but a greater degree of restraint and sophistication does have to be employed. As the product becomes more expensive so does the style of promotion. People who can afford quality expect that same degree of quality and sophistication from their advertising and promotional material.

■ The spread left by Blake Miller uses Serifa 45 with hung caps. giving the appearance of wooden type. In its printed size the white type works well. The Vaughn/ Wedeen design below left for Richard Yates Architects uses colour in a much more subdued and subtle manner. Even more restrained is their brochure for the Western Bank Plaza below. Each page features large raised initials with very open line spacing on a grey/lilac paper opposite highquality photography with a similar lilac tint on white. They are very tasteful designs.

THE MASTER BUILDER

Today's architect must constantly strice to keep up to date with the rapidly advantage technology in the building industry. New and better methods are always being perfected, so it is imperative to remain abreast of each and every development. Yet, in order to be truly successful, architects must not only keep pace with the present, but also understand and implement the principles of the past. At Richard Yates Architects, Inc., mastering new techniques is important, but we place an equal amount of importance on the fundamental principles that have developed throughout the history of architecture. The necessary melding of past and present is a challenge that is best understood by reflecting upon the architect of earlier times—the Master Builder.

The architecture of the Hennissance period best describes the seemingly lost art of the Master Builder. At that time, if a cuthednal was able to impress the public with the vast amounts of space its vaulted reiling enclosed, it was considered access, adoptate import was a stal our of a building's function and purpose.

Famous Henaissance buildings such as St. Peter's Cathedral were designed by architects who were primarily pointers and settlytors. They were not concerned with complicated books of government building codes, or the need for electrical wiring, boat ducts and plumbing. However, a Henaissance architect was also expected to design such dissimilar projects as roads, decorations for festivals, and aquaducts and bridges. His primary role was that of an artist and an engineer. In spite of so many diverse responsibilities, the architect of the past had less concern for many of the functions that complicate the present. After all, a single building wasn't required to fulfill multiple purposes, and roads did not need to inuffe Be-wheelers and roads four traffic.

The architect of the Renaissance was more single-minded in purpose, yet less constrained by time. This enabled him to pursue a wider scope of projects while retaining full control over all aspects from inception to completion. ARCHITECTURAL ORIGINS

"It hitecture is the art which so disperse unid adorts the edifices saired to may that the night of them contributes to his mental health, power, and pleasure." —John Huskin

The Invisible Message

This section might seem a slight digression from the main subject of typography, but it is an area rarely covered in design literature, although all designers should have an appreciation and understanding of it. It is the area of 'colour blindness', or 'colour deficiency' as it should more accurately be called. Not everyone has normal colour recognition — in fact, the problem affects a very large percentage of the population. The overwhelming majority of people who have some degree of colour deficiency is male. The percentage of men with colour blindness is somewhere between one in ten and one in twelve, whereas the percentage is as low as one in 250 with women.

Before moving onto the actual manifestations of the forms of colour deficiency some general background information might be of interest to you. I hope that what I'm about to say doesn't sound too much like a section out of a medical journal, but I think it could be both beneficial and of general interest.

Colour vision is defined as the ability to perceive hue, colour brightness, and colour saturation corresponding to the normal visible wavelengths between the infra-red and ultra-violet bands of the light spectrum. Normal vision can distinguish around 160 basic shades.

The most common colours that people have problems differentiating are red and green. Only a very small percentage of people have difficulty with yellow and blue. Total colour blindness is almost completely unknown. Figures as low as one in 100,000,000 are quoted for those who see life in monochromatic tones only.

It appears that more of the people who suffer from a red-green deficiency live in the developed world, as opposed to peoples such as the Australian aborigines and native Indians of the South and North Americas. It is interesting to note that the red-green deficiency is higher in Europe, becoming more manifest in groups where there is a high degree of inter-breeding such as with the Merronites, Mormons and similar groups. This is perhaps not so surprising when you know that colour deficiency is an hereditary congenital disorder, transmitted through the X-chromosome. This particular chromosome is recessive in the female, which explains why colour deficiency is low in women. Unfortunately for people born with colour deficiency there is no cure, as it is caused by a defect in the light-sensitive cells of the retina.

As you would expect, certain careers demand a

Right These two photographs of a bowl of fruit, which are actually identical, show left how colour is perceived by people with normal vision, and right, how it is seen by those with a red colour deficiency.

perfect sense of colour recognition. Pilots, naval officers and train drivers all have to pass the appropriate tests; electricians also need to be able to distinguish between the different colour codes of wiring. Obviously in the field of design it is also important, but not necessarily vital. Interior and fashion designers need a perfect colour sense, but there is no reason why copywriters and, to a lesser extent, typographers should not be able to have successful careers in the communications industry with some degree of colour deficiency. It is an interesting theory, but women do seem to be extremely successful in certain areas of the design world where a greater degree of colour sensitivity is required. One must assume that there is a strong link between this and the extremely low numbers of women who suffer from colour deficiency.

But how does all this affect the designer? I'm not suggesting that everything you design should be directed away from certain colour combinations, but an understanding of the common problems of colour deficiency, and its manifestations, could mean a subtle change of colour here and there to your designs, which would make them just that little bit easier to be understood by everyone. After all, who wants to lose 10 percent of their readers even before they start?

■ Above An advertisement to promote Canon colour copiers. It is an interesting idea, but what about those readers who suffer from a green colour deficiency? It must surely defeat the object of the exercise if you're going to

produce an advertisement that some people won't be able to understand!

■ Right These examples illustrate exactly what I mean. The four stamp designs, conceived by Tayburn and illustrated by Magnus Lokhamp, were issued by the British Post Office to portray medieval life. If you look at the 17p stamp below right it contains areas of similar tones of red and green set against and ochre background. People with a green or red deficiency would find it extremely difficult to distinguish between the trees on the slopes and the birds in the tree. With due respect to the designer of an otherwise delightful design, a small modification to the tones of these colours could have helped their appreciation by another 10 percent of the population. The illustration below shows how the stamp would look to someone with a green deficiency.

As if it is not enough to think about the readability of type in colour, designers also have to be aware of how legible their designs will be when converted into black and white. Although a very high percentage of television sets in the western world are now in full colour, there is still an exceptionally large number of monochromatic sets in regular use. In addition leaflets, books and magazines often contain black and white reproductions of work originally designed in colour, and most advertising at some stage is reproduced in black and white. If the colour values are not well balanced, the message will be illegible in black and white.

■ Above and left This colour design by Grundy & Northedge for The Contemporary Art Society has used a strong blue – normally recessive – with a weak orange – normally dominant. When copied

monochromatically the blue recedes and the red content in the orange starts to advance. This then produces a reasonably balanced design in its new monochromatic form.

PARTTWO

COLOUR

Mood and message

Part Two: **Introduction**

Now for colour. The most interesting aspect of the subject, but one which can easily lead you to make the wrong choice, is that it can be all things to all people. Green, for example, can be perceived as violent and exciting, a colour which signals an alert (as in traffic lights), and one which can be associated with envy, disease and decay. On the other hand it can signify calm and peace, having associations with nature and the countryside and a healthy way of living. This wealth of symbolic

associations is shared by all the other colours in the spectrum.

With just this one example it's easy to see how colour added to type increases the message of the type and is therefore an essential part of the design. But it will work only if the designer understands the properties of the colour and the effect he or she is trying to create.

The following chapters take you through the range of aspects that have to be considered when

choosing a colour: its symbolic associations; its volume and vibrancy — does it shout? Is it bright? Or is it pale and soft? Its temperature — is it warm, or cool? Its market appeal — is it stylish or cheap? Is its image one of tradition, security and dependability, or is it modern, dynamic and innovative? And lastly, its decorative value. In each chapter I have selected examples that compare the different uses of colour and the variety of effects that are achieved, from travel brochures and promotions to the packaging of food products, pharmaceutical and natural health products, advertisements for the arts and other forms of entertainment, engineering, cosmetics and sports.

These images illustrate the wide scope of colour in typographic design, from billboards to packaging, calendars to posters.

S eeing red!

Many colours have messages that are internationally recognized and symbolize various actions, warnings, or products the world over. The most obvious example is the code for traffic signals: red for stop, green for go. Although it is very easy to fall into the trap of generalizations, colours do have certain properties that remain the same through the pendulum swings of fashion which affect other aspects of colour, such as acceptability and popularity. It is these properties that convey the message of each colour.

By 'properties' I mean aspects such as volume, excitement value, temperature, and symbolic value. Let's start with volume. There are quiet colours, such as light blue, light pink, and soft grey, and there are loud colours, such as bright reds and bright greens. Their 'volume' comes from their dominance (how much they seem to jump out at you), or from their recessiveness (how much they sink into the background). Dominant, or loud, colours are aggressive, whereas recessive, or paler, colours are passive.

You might use quiet colours for a product such as a fabric softener, with its connotations of soft blankets and woollens, but it is unlikely that you would use loud colours for such a product. You might use loud colours for a food product, such as salt, which will appear on the supermarket shelves among containers full of the same product, and choose bright colours such as red and bright blue on white, simply so that your product will stand out from all the rest.

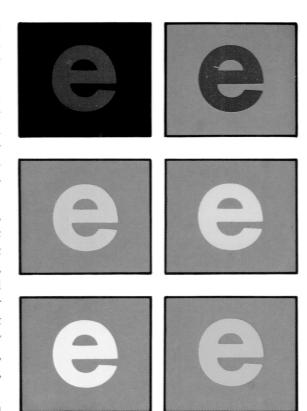

■ This set of six letters illustrates how colour dominance can vary depending on the colour it is set against. The red on the grey background is very much more strident than the pink, blue, yellow

and green on the same background. These techniques of colour contrast and blending are used extensively in packaging design, as will be illustrated throughout this chapter.

Of course there are other considerations to be taken into account when choosing a colour, and they all combine to create the final product, but each must be assessed on its own before the whole is put together. So, onto the next — excitement value. 'Excitement' can refer to warning, danger, risk, and fear. The colours used most commonly to signify excitement are red and orange, used extensively in the areas of poisons and lethal chemicals, explosives and road hazards; but, particularly in the case of red, they also represent blood, horror and revolution. Conversely, for products with no excitement value, a designer may want to put across the opposite image and use safe colours. These are usually blues, browns, dark greens or greys.

- Left Black and red are traditional warning colours, found in nature and in our cultural symbolism. Red is an easy colour to see, particularly from a distance, and is therefore commonly used to signify potentially hazardous areas on the road or the pavement.
- Below This sign outside the Rockefeller Centre, New York, is a pleasing design which commands attention mainly by its good taste. The introduction of a warm brown blends well with the surrounding environment.

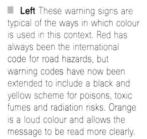

Colour temperature

Colours also have *temperatures*: yellow, orange, red, purple and pink tend to be warm, whereas blue and green are cold. However, the shades of each colour of the spectrum can have a temperature which is the opposite to that of its pure colour — a pale yellow, a pale pink or lilac can be cool, whereas a yellow-green can be warm. The temperature of colours is significant in designs where you might want to indicate heat, such as in travel brochures which advertise holidays in the sun, or coolness, such as in an advertisement for a refreshing drink.

Below This typographic design from Tim Girvin Design is an interesting example of colour and temperature change within a single image. It moves from the heat of the bright red through to what would normally be termed cold white, but here the title itself sets up an association with white heat, so that the colour is 'warmed' by the mind.

- Above This example, also from Tim Girvin Design, is really self explanatory in both colour and typographic use.
- Left By contrast, this example from Minale Tattersfield has used warm colours in a quite different way here they suggest the freshness of fruit.

The *symbolic properties* of colours are the most readily recognizable — we are all aware that light green conveys an image of tranquillity and calm, blue signifies water and hygiene, orange and yellow suggest the sun, purple has overtones of pomp and ceremony, and browns are harvest colours. Colour can have symbolic value in every area from natural health to medicine, politics to sport. I have chosen the following examples from several of these areas to demonstrate colour association with product, and also to point out the anomalies.

■ Far left and left Blue is usually considered to be a cold colour, and these two examples take full advantage of this property. By restricting their crisp design to just two tones of a cool grey/blue, Pentagram has produced just the right feel for a poster to promote an Everest expedition. The monochromatic approach to the label for a white wine aperitif, designed by Minale Tattersfield, has also concentrated on all the cool qualities associated with blue.

Above The chocolate box from David Davies places green alongside white and a cool grey, as opposed to a warm grey, to create the right cool temperature for a mint-flavoured product.

Feminine colours

Colours can be used to suggest gentleness and caring, and can be associated with feminity and motherhood. Such associations occur most frequently in the area of packaging, particularly in the promotion of items for the home and for young children. The tendency is to choose pastel shades for such promotions, and designers rely heavily on light pastel pinks, blues and yellows, often with a hint of grey within their basic palette.

Above and right These two examples of packaging by Coley Porter Bell are for similar products but their colour schemes create totally different moods. The softer design for the 'Moods' air

fresheners has colour associations with spring mornings/summer days/autumn/ evenings, whereas the stronger colours on the stick-ups are far less subtle in their message.

Above and right Here is another contrast in approach. Both examples use pastel colours, but one product is to be sold through a chain of upmarket outlets, whereas the other is aimed at high-volume supermarket sales. The Next range of body products, above, designed by David Davies, uses very subtle colour changes

and has very elegant appeal, whereas the colours of the Asda fabric conditioner packs from Lloyd Northover, **right**, are far brighter, though still using basic pinks and blues to stress softness. They are thus more suitable to the high-volume competition on the supermarket shelf.

■ Above Generally speaking a much heavier design approach is required for most pharmaceutical packaging than for softer, more soothing products. But the two packs by Minale, Tattersfield for Timoptol, in pale grey/blue and grey/pink manage to stress the gentle action of the product while retaining a clean and clinical look.

■ Left The cover design for this drug company report was produced by Pentagram UK. The whole of this publication stresses the concept of care, and this is reflected in the colours used, as well as in the choice of illustrated material and the restrained typography. This restraint is typified by the white out of pale blue.

■ Below The logo for the Cooperative Health Care Plan Inc. shows an alternative approach to suggesting cleanliness and efficiency – pale colours on a grey ground.

■ Left Although bright colours could have worked for this book jacket because health is a lively subject, it was decided to use softer colours, which are associated with the gentle treatment of pregnant women.

Fresh colours

Colour is also used to suggest freshness, with bright blues, greens and yellows being the colours most often chosen where vitality and sparkle are associated with the product. Obviously, where there is an association with fresh water and coolness, blue has a prominent role, as does green for the promotion of field sports and other outdoor pursuits. Fresh fruit and vegetables, which stress freshness and goodness ask for the same kind of treatment, stressing freshness and goodness.

The use of pastel colours is also much in evidence in packaging for pharmaceutical products, but the nature of some products, such as medicines, demands that they be presented in a bright, fresh, clean manner, suggesting much the same quality of health associated with eating fresh fruit and salads.

■ Above These pack designs for 'Slip Not' boat mats, designed by Lloyd Northover, combine the obvious colour-association of nautical sports with the safety

aspect of the product. Set against a blue background the letter O takes the form of a lifebuoy with a red spot, for danger, inside it.

Above The use of a strong refreshing blue as a background colour to this display of foot-spray products designed by The Partners works well because clear blue suggests cleanliness and coolness.

■ Right Predominantly blue and yellow, the Martini drink ads concentrate very much upon the 'cool and fresh' approach, combined with the theme of swimming and sunbathing.

■ **Below** Products like these also need to be marketed with a 'cool and fresh' image. These pack designs, by Minale Tattersfield for

the Boots 'Shapers' products, stress their qualities by the use of the appropriate colours for each flavour.

- Left This design by Fitch for the sporting goods section at the Samaritaine department store uses the obvious colour choice – blue and yellow – to good effect.
- design by Richard Mellor continues the natural theme of green as a sports colour. For a tennis tournament poster it would have been quite difficult for the designer to have used any other colours than green, yellow and white.

Right This brochure for Artemide Lighting, by Richard Mellor, uses the same colours as the tennis poster above, but the designer could have used any combination of bright colours because there are no particular colours associated with light.

■ Above in Banks's & Hanson's real ale poster the earthy colours, nostalgic use of ceramic tiles and mock-Victorian letter-forms are all a quite deliberate attempt to convey the feeling of traditionally brewed beer. The advertising agency was TBWA.

■ Right In this interesting logo for the Sanbusco Market Centre, type style and colours combine to capture the feel of the Old West.

Healthy colours

Not all health foods are promoted with bright colours. Following the current trends toward healthy eating habits we are now eating more and more cereal products. This has led designers to gravitate toward the subtlities of earthy browns and ochres to promote many 'traditional' products, which are much more in vogue now than they were in the past. Such colours are used not only to symbolize the natural, organic and healthy aspects of the produce but also to suggest tradition and evoke feelings of nostalgia. Other earthy colours used in this context are dark greens, deep golds and dark reds.

■ Left Smiths' Do-It-All chain market their own range of gardening products. These David Davies designs combine a 1980s style of typography with traditional woodcut illustrations which, combined with the earthy colours, create a definite up-market 'organic' look. The use of more saturated colours below left gives these Fine Fare beer kit packs greater mass-market appeal than the gardening products. The design comes from Coley Porter-Bell.

Left These designs were produced by Minale Tattersfield for the Boots 'Second Nature' wholefoods packs. It's not just the earthy colours that are important here, the visual imagery is equally so. The wicker basket, wheat grains, honeycomb and fresh fruit are all important elements in developing the visual idea.

■ Above Coley Porter Bell's flour pack designs for Jordans have a similar approach to the Boots example, again stressing the health-food angle. The customary colours (ie. red and blue) associated with flour bags for sale in a supermarket would not work for this 'wholefood' market or for this design.

Vibrant colours

Just because current trends are moving very much toward the use of pastel and earthy colours doesn't mean that there is no longer a need for strong, bright ones. There will always be an occasion to suit a particular colour scheme, and strong, vibrant colours will always find their place — the pure primary and secondary colours with little or no subtle variations, the reds, blues and yellows from which are made the secondary greens, oranges and purples. These are the attention-getters — the powerful communicators.

Above The cover for a piece of literature publicizing the developments in London's West India Dock Development Corporation. This attractive and well-balanced Fitch design uses a traditional motif and face but the colours are eye-catching.

■ Above right Trickett & Webb designed this simple but striking poster for an exhibition of 20th-century chairs at the RIBA (Royal Institute of British Architects). The use of a solid, primary yellow as a background for the chunky type creates a strong image which can be used for a variety of carriers such as swing tags and the catalogue cover.

■ Left and right Two bright pack designs from Minale Tattersfield. The soft drink can, right, has obvious colour associations, but the colours for the adhesive packs, left, have been chosen purely for their attention-drawing qualities; they need to be noticed on the store shelves.

- Right These discordant colours used on Kronen Audio stationery have been used to create an exciting visual effect in the modern idiom. However, I feel that reading a long letter on such a colour might be both tiring and difficult, which really defeats the object of the exercise.
- Below The designer may possibly have chosen blue because of its satellite and sky associations, but the contrast of white against blue makes the message shout out in an extremely effective way.

- Left Logos for political parties must project a specific image and be distinctive from those of other parties. Although the flag of the British Labour Party stood out, it looked rather too revolutionary and has recently been replaced by a red rose logo. The emblem of the SDP/Liberal Alliance is a far more staid and straightforward design.
- Above The style of this foursheet poster for Persil washing powder is typical of the J. Walter Thompson approach to promoting this particular product. Good, strong vibrant colours are all contrasted against the brightness of white.

Exciting colours

So far the colour schemes illustrated have been fairly controlled, and have fallen into various categories, such as pastel, earthy, vibrant, and so on. But what of multicolour projects? A fresh and courageous approach to colour application can open new doors, and colour can be used in a fun way to evoke moods of elation, frivolity or excitement. The implementation of such colour schemes, however, can be extremely difficult, and mishandling can prove disastrous. Among the many pitfalls are imbalance, loss of clarity, and colour clashes, but is should be mentioned that colour discord can sometimes be used deliberately to create tension and heighten the mood of excitement. The applications of such colour schemes are numerous, and can often be seen on billboards and supermarket packaging where striking colours are essential in a fiercely competitive environment.

- Above The brightly coloured snack food packs designed by Fitch for the Marks & Spencer chain are typical of designs for products which require highprofile shelf exposure.
- Right Washing powder cartons commonly feature bright colours to reinforce the vision of dazzlingly clean clothes. These packs from Lloyd Northover are among the brightest of all.

■ Left This tantalizing book jacket, designed by Peter Bridgewater Associates, uses colour well to evoke the sweetness and light of desserts. It provides a good background to the title of the book which, set in a dark brown, suggests chocolate.

Above One of the Royal Caribbean Cruise posters by the advertising agency, Travis, Dale & Partners. This example uses colour primarily to create a mood of fun, warmth and relaxation, as does the handwritten catch line. Most holiday advertising is published mid-winter when bright and varied colour schemes cannot fail to attract the attention of sunhungry people.

Above Each of the Atari computer game packs has a simple design featuring one dominant bright colour which conveys a sense of fun and excitement.

■ Right The green and pink type for the passion-fruit drink
Maracuja enhances the exotic,
tropical nature of the drink.

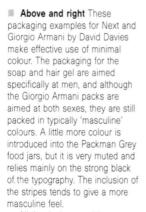

All the designs on this page are from David Davies, except the two 'Pepe Grafters' swing tickets, which were designed by Worthington. Their two-colour style puts them very much into the same category as the Davies examples.

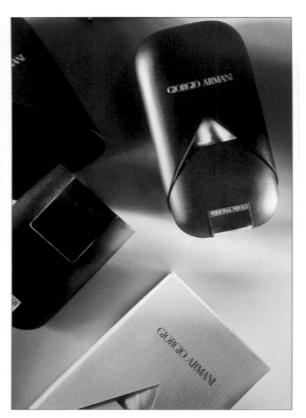

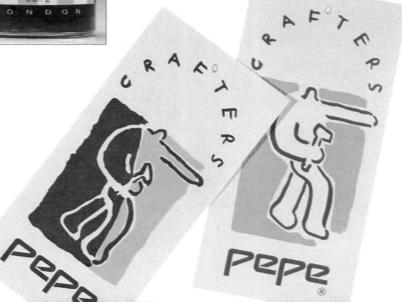

Masculine colours

As we move toward the end of this chapter let us look into the more restricted uses of colour and ways in which its message is put across. As often as not, economy is a reason for a reduction in colour, but this is not always so, and there are instances where, although four-colour reproduction has been available, the designers have deliberately opted for a more monochromatic approach. This can be seen particularly in the packaging of men's wear products, where a strong message of masculinity, or sometimes sophistication, is often required. It is also evident in the corporate image of some companies who wish to convey an image of solid dependability, rather than colourful frivolity.

■ Left A single-colour design for Mason Fedyk by Richard Mellor. Although it is a simple white-out-of-black design and uses a basic sans serif typeface, its appearance is both sophisticated and masculine.

Left The Boots gift towel pack by Trickett & Webb is the only example here to use saturated colour – red – but it still works in the context of the other colours – black, brown and dark blue.

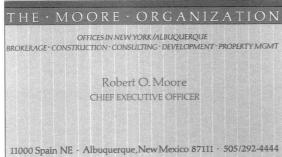

Right These packs by Minale Tattersfield for Harrods continue the themes of formality and dark colours to create masculine image.

Right The Suchard chocolate pack designed by Minale Tattersfield uses gold with brown so that the browns are clean rather than earthy and give an impression of smoothness and high quality. Similarly, the jacket for the Roux-Brothers' book on patisserie, far right, incorporates marbled paper and gold together with classic typography to enhance its perceived value.

Above The Louis Vuitton shopping bags by Fitch use brown in a similar manner to the Suchard pack. The discreet type treatment heightens the sophisticated effect.

Sophisticated colours

Finally, we come to the use of colour to create the impression of opulence, sophistication and high quality. Such colour schemes invariably contain quantities of gold or silver, which are often mixed with other colours to create metallic blues, browns, greys and maroons. There are no rules for such schemes, because no single product has a monopoly on the suggestion of quality. A colour scheme which might at first sight suggest high-quality automobiles can apply equally well to mint chocolates, bath fragrances or expensive wines, indeed any commodity where an upmarket profile is needed.

Above left The musicprogramme cover by Cope Woolcombe & Partners creates an atmosphere of sophistication by the use of gold with black in the overall pattern and graphics from the Vienna Secession. Above Coley Porter Bell's butter pack is included here purely for the gold, which lifts its perceived value. Without it this would be a mundane design in fresh, spring colours. **Left** In the design of this 'Country Houses of England' portfolio, by Grundy Northedge, the marbled paper is used again, to hint at tradition and quality.

■ Above right The Johnnie
Walker Black Label Scotch pack
(Minale Tattersfield) uses gold and
black to create an image of
sophistication. In the same way
marbled paper, used for Harrods
chocolate packs and designed by
Minale Tattersfield, lifts these
chocolates out of the ordinary.

T he colour of your money

When you are designing type with colour you have to bear in mind the market at which the product is aimed. You are relying on colour association of a different sort — the image conveyed by the colour, whether it be one of status, fun, glamour, dynamism, security or tradition. This is in turn affected by the social group the product is directed

at. It is also affected by the product itself — a sophisticated colour for one product may look vulgar when used in conjunction with another.

The markets you have to consider are varied and include such opposites as young or old, affluent or low-income, glamorous or earthy, national or international character, classic or modern. For

Right and left The transformation in the packaging of Guinness. The post-war design, far left, was updated in the '70s. by J. Walter thompson, left, to appeal to young sophisticates. They introduced a new modern typeface - Hobbs Stencil - based on stencil lettering, and changed the colours so that the black and red stood out against the cream background. The label was strong then, but ten years later it seemed brash. Coley Porter Bell redesigned the new label, below left and right. They reintroduced the oval shape from the original label, and the caption 'Brewers since 1759,' but modified the Hobbs Stencil face subtly to produce a lighter, less chunky style. The cream background was replaced by a dark one and the oval now contains a manuscript yellow, giving it a more traditional

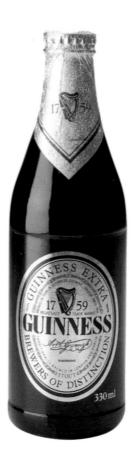

example, you may choose to design a poster advertising a pop concert using fluorescent pinks, oranges and greens because you know that these aggressive colours attract attention and, moreover, will appeal to the age group that will want to go to the concert. But you would not use these colours for a poster advertising a sing-along for 60-year-olds.

Every product in which graphic design is of vital importance is affected by these considerations, from the automobile industry to banking, engineering to fashion, cosmetics to food products. I've selected examples of the various images and products to demonstrate how colours do and don't work, in portraying the right image. However, I think it is a good idea if you select images from magazines or posters and analyze them yourself in terms of the characteristics I've mentioned, and try out different colours to see what differences the colour changes make.

Right This traditional wine label, for Baron de Luze Claret, uses upmarket colours (gold and maroon) and classical typography. Centre right Two four-colour labels for a downmarket German table wine use brighter, more robust colours. They make an interesting comparison with the austere but classy calligraphic label for a Californian champagne, far right.

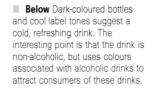

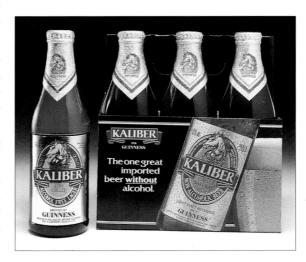

■ Right The soft, laid-back colours and biscuit-coloured type on these Harrods' tins evoke the country goodness of homemade biscuits.

Food and drink

It's stating the obvious but every person in the world has to consume food and drink — without them there would be no life. But it's difficult to form a colour association with a food or drink other than it's natural colour. However, even these basic commodities have fallen into the hands of the market strategists and every edible and drinkable substance now has an association with a particular class, age group, culture, wealth, etc. It is these values that are conveyed by typography and design.

■ Right Ice-cream cone packs design by Minale, Tattersfield. The blue, pink and yellow, and the soft browns, are appropriate to the product, as is the gold and silver aluminium, which hints at the iciness of the ice cream.

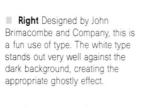

Jacksons of Piccadilly

JACKSONS of PICCADILLY

JACKSONS OF PICCADILLY

Above and right The development in the packaging for Jacksons of Piccadilly's range of quality teas, designed by Coley, Porter, Bell. The sample packs top right were a progression from the original logo, above, they illustrate modern packaging but don't have quite the right feel for a quality tea product – the type and the coloured illustrations are too heavy, and not subtle enough. The dummy pack far right is a more refined design, using restrained.

dark colours, but it's lifeless and wouldn't stand out well on the shelves. The final results did pass the test though. The herbal teas **right** are colourful but with a light, delicate touch, and have the suggestion of country goodness synonymous with a herbal product. The real teas, **below right**, have a dark background which gives a feeling of quality, but the subtly coloured illustration makes them distinctive.

Above A fine example of the use of pastels in a new skin-care range designed for Almay by Fisher, Ling and Bennion. The design brief required the designer Bill Jones to produce an upmarket image to reflect the range's prime position. This sophisticated solution links products, with no range title, by image and design only. I like the clever use of the triangle, symbolizing an A, to denote the company name.

Household products and toiletries

Like food and drink, colour can be associated with toiletries and general household products. The function of toiletries is hygiene and cleanliness, and it therefore follows that their colours and images must portray those same values. In general, out go the blacks, greys and dirty browns and in come the pastel tones, the creams, whites, etc. But household items are so varied that you can't really define any one area of value or image, and fashions dictate to some extent which colours you use.

- Left A good example by Lloyd Northover of how a colour scheme can be rotated to produce colour-coded packs. The colours are deliberately soft, reflecting the airiness of these various hair mousse products.
- Above You could cover the label of this product completely and it would still say, 'These contents are spring fresh.' This design by Pentagram for Clairol is a superb use of bright, fresh colours and clean type.

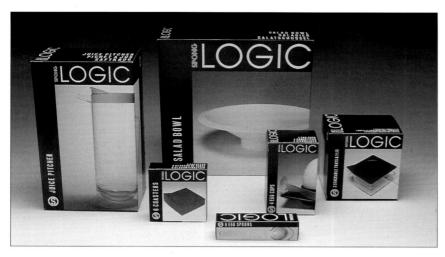

■ Right The colours associated with irons need to be handled with care and control. This particular packaging is recent and is an attempt to update Morphy Richards' dull and old-fashioned image. The new look, including the re-design of the company's logo, moved the brand upmarket at the same time retaining its traditionally sympathetic and friendly image.

■ Below An example from a new series of packs to promote Action GT toys, designed by Minale, Tattersfield & Partners. The approach was one of 'honesty,' of not resorting to exaggerated, overdramatic and gaudy drawings, but instead to present photographs of the game or toy being played with, with obvious enjoyment.

STOMPER 4 3 pear power and 4 wheel drive for high speeds, bright speeds, bright speeds, bright speeds and super-starts.

■ **Right** A series of microwave packs designed by Trickett & Webb. The minimal use of colour gives a cool feel to the packs, but this serves to convey an image of quality, aided by the open spacing of the type.

A fun approach to packaging for children's shoes by Pentagram UK for the Clarks shoe company. Above the use of flat, strong colours - green, red and yellow appeals to children and catches their attention, while at the same time establishing a corporate identity for Clarks. The motif of a square divided into two triangles was derived from children's coloured blocks, and is repeated on all the packaging. It was adapted for the lettering on the shoeboxes, right, which appears as a stencilled typeface on a coloured block. The colours on the boxes work well because they serve to colour-code the shoe sizes and form a colourful frieze along the walls. These colours work equally well on the Clarks shopping bag, above right, which includes a particularly nice touch, with good strong typography explaining the reasons for sensible foot care.

Clothing

As far as the industrial world is concerned and, increasingly, the Third World, it's not possible to sell any item of clothing in realistic production quantities without a full understanding of current fashions in colour, functions and age groups. Colour associations for clothing cut across all sections of society — rich or poor, young or old. Many people use fashion as a means of trying to improve their self-confidence and respect, or to make a statement about themselves, and it is these psychological aspects that are exploited in design.

The biggest area in fashion for variation within colour values and image is age groups. From

children's clothes to teenagers' garments, twenties to middle and old age, the colours and images are radically different.

Above, a fine illustration of how current graphic trends can be applied to shop-front design. Modern pastel tones are used to tone down the plain blue of the torn paper style background. Above right Burberrys have used very upmarket, simple, classic typography and good, strong but plain colour.

■ Left The common design feature of blue jeans is their fabric and their colour and there is little to identify one maker's blue jeans from another's. Levi's have solved this problem by concentrating on the hardwearing toughness of jeans. Their hard-hitting caption reinforces the image of their product.

■ Above The pastel tones of Burton's shop fronts are echoed in these packs for their own-brand tights, at the same time conveying the softness of their product and an upmarket image. In contrast, the colours used for the packaging of Pex children's socks, above left, are bright and primary – children's colours, if you like – the colours serving as an identification of foot size.

Right The selling of the dream. Typical examples of promotional material for annual holidays. The prominent colour scheme always includes the use of clean blues. with not a cloud in sight. The prerequisite of practically any holiday is fine weather, and this is what the brochure designers are promoting. The blue chosen for winter activity is clean and crisp it contains an air of freshness whereas the blues chosen for traditional sunbathing holidays are warmer, and oranges and warm yellows usually find their way into the layout to increase this feeling.

Travel

Travel is concerned with the promotion and selling of a dream, the dream of escape, something new, different, and perhaps exciting, away from the routine of normal day to day living. But it means different things to different people and this affects the colours that are associated with each kind of vacation that is promoted. To some, leisure means sunbathing and swimming, therefore the colours must convey a feeling of warmth and rest; to others it means winter sports, and similarly the colours must reflect the winter environment and activities; others enjoy a rest in the countryside and the colours again must convey a sense of peace and tranquillity. The graphic designer's palette must sell the particular travel activity, the individual's own particular dream.

Right These travel promotions have a more simplistic approach than those on the opposite page, but perhaps this is because the market is different. The layout style suggests that it is appealing to the teenager at the lower end of the market. However, the photographs illustrate people in their twenties with money to spend. In addition the dominant vellow is cool when it should be warm, body copy runs over patterned tints which reduce readability, and to me these designs do not understand their market.

CUNARD APC

But our philosophy is still summed up by the diction of one of our famous past captains.

C General M Supplied N Prince A N R D

Left This design understands fully where its market lies. The choice of colours and typeface. its generous spacing, the clean uncluttered layout, and the high-quality photography all evoke the golden years of sea travel and promote a similar sense of opulence now.

Thomson

Right Four beautifully colourful designs for television from the NBC network. Now that the computer has well and truly arrived in the TV studio we are able to see more and more examples of highly creative, animated title sequences for all k nds of programme. Some of the most imaginative sequences can be found as the introductions to news and sports programmes.

Art and entertainment

Art and entertainment promotion is very much to do with the creation of mood. The imagery, combined with the relevant colour scheme, has to appeal to the senses, it has to provide an expectation, promise a new experience in much the same way as travel promotion does. Colour use for film and drama must suggest the visual story, whether it is drama, tragedy, comedy, farce, modern, or traditional. Similarly, for music, the appropriate colours should be used — loud, vibrant, soothing, discordant, avant garde or traditional.

Above and above right Two contrasting styles of poster.

Although the 'Sid & Nancy' poster contains modern colours which appeal to the younger audience at which the film is aimed, overall it is restrained alongside the cisturbing design of the 'The

Draughtman's Contract.' I would have preferred the latent violence of the 'Contract' poster for the Sid Vicious example – it would have been much more appropriate.

Right A poster advertising an exhibition at the Boiler House, about good and bad taste. The Roman T, made out of wood, symbolizes good taste, and the furry E on the dustbin, bad taste. As an overall design it is quite stunning.

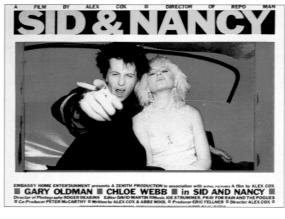

Below, the classic yellow and black caption identified with Deutsche Grammophon has become a distinctive trademark associated with classical music (it makes a good foil for the medieval romp beneath it). On the other hand, the cool grey and white and widely spaced type on the Eurythmics record sleeve, right, establishes it as a modern, sophisticated production.

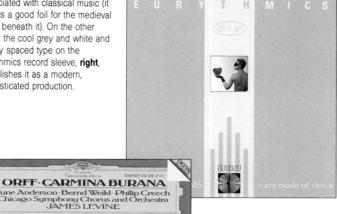

June Anderson Bernd Weikl Philip Creech Chicago Symphony Chorus and Orchestra JAMES LEVINE

Top and above These posters for fine art exhibitions are very similar in that they both have a background of dark sophisticated colour with strong typographic titles. I like the shadows on the word 'Contact', created by the red arrows, which emphasize the title even further. The 'Max Ernst' poster plays safer, sticking to a classic Roman and italic typeface.

Two designs by Vaughn Wedeen Creative, Inc. Above right Classical flourishes soften a strong, condensed, serif face, and muted greens and reds create a cool, elegant effect. The brochure, right, has used classic images with a humorous touch and with modern pastel colours.

■ Below Normally, magazines are designed against unrealistic for deadlines. But in house quarterlies more attention can be given to refinement, as shown in

the well-considered run-around type, in this spread from Skald, the in-house magazine for the 'Royal Viking Line' pleasure cruise company.

Publications

All that is applicable to art and entertainment in the use of colours in typography is also relevant to the world of publishing. There are thousands upon thousands of daily, weekly, monthly and quarterly publications all over the world, describing everything from computer software to botanical shrubs, from herbal remedies to the 'Life & Times of Mickey Mouse'. They are aimed at every conceivable section of society, and suggest every kind of mood and image. Again it's the designer's function to evoke the appropriate feel and colour association for each particular product.

■ Left In the case of a monthly magazine such as 'Elle', time considerations are more in evidence. Even so, this particular magazine, which is aimed at upmarket women, must maintain certain standards of design and creativity. This particular spread has moved away from the general style of the magazine in an attempt to create a fresher, livelier layout, and a design suitable to the particular article.

Left and far left A book cover and double-page spread which show a rather striking style for book production. The text reversed out of the black ground on the cover looks good, but generally speaking readability does suffer quite considerably. In this case the strong flat colours of the stencil typeface stand out well on the background and would be eye-catching in any bookshop. The red grid on the spread works well to delineate the columns of text and lifts the design out of the ordinary.

CITY

Proceedings of the state of the

The magazine City Limits is known for its anarchic style. In the 1983 example, above, images were deliberately placed over the type to obscure it and the primary colours in vogue at that time exploded out of the page. The current style, right, has 'bastardized' typefaces via the computer, destroying their form and design.

NO EASY WALK

75 YEARS OF TO FREEDOM
THE ANC FROM CIVIL RIGHTS TO CIVIL WAR

Music for yuppies! MiCRODISNEY, the truth

MANDSWORTH SONGS: Black filmmakers and desire
IAN DURY, MOVIES and the MINERS STRIKE

Above A double-page spread from a rather large children's book by R. Meal called 'Get Fit & Fiddle in the Kitchen.' Its approach is very similar to that of Clarks shoes, on page 102, in that it's great fun, has lots of colour and

large readable type. It's just the right thing to encourage children to think healthily about their eting and living habits. It's so well done, I suspect that quite a few adults will be taking a sneaky read after lights out.

Far left, left and below Banks now realize that they are in the marketplace just as much as anyone else who is selling, whether the product is silk stockings, automobiles or hamburgers. The Midland Bank understands this requirement, and like all big banks, they're very anxious to encourage young, first-time investors, students and graduates who will soon have money to save. Just look at these examples - they are tastefully done, have good design and well-balanced colour, but they're not stuffy. It is very likely that they will attract young investors.

Left It's not only the literature of banks that has changed, the imagery of their exteriors and interiors has also been modernized. In come softer.

recessive colours to project friendship and instil confidence in the potential customer. Note the banners showing their interest in the student market.

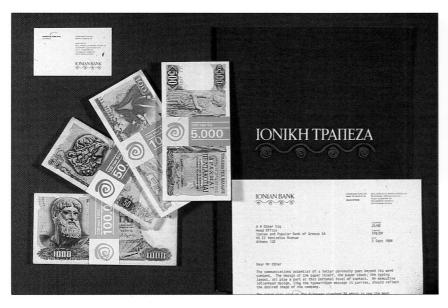

Left In this brochure cover to promote 'The Ionian Bank,' blue is the dominant colour, not a weak watery blue, but one that is strong, sound, and solid – characteristics that you expect from a bank.

■ Above Not as friendly as the lonian Bank is the image of the Chase Bank. It has the qualities of strength and solidity needed by a financial institution, but does appear somewhat forbidding.

Above In contrast to their literature for young investors, the design for the Midland Bank's guide to investments in the tax-free Channel Islands and the Isle

Man is aimed at wealthier, more serious investors – the colours and type have been adjusted accordingly.

Banking and finance

Banking and finance make an interesting comparison with some of the previous design areas in as much as, although their objective of evoking mood is identical, their actual implementation of colour is much narrower and more clearly defined. Most financial institutions will steer clear of strident. bright colours with good reason — they are trying to persuade people that they are serious about looking after their money. So safe colours, mainly of a recessive nature, (such as browns, greys and blues) are usually used in a careful attempt to project friendship and instil confidence in the potential customer. However, some banks and other institutions are breaking away from their traditional image to appeal to younger savers, and this new, brighter image is reflected in the colours that advertise them.

Below A new brand image for Thorn EMI Lighting by Cope Woolcombe & Partners. The logo is clean and strong, with the design of the 2D echoing the lighting that this company produces. Below right, the Omega and Mini-Spot ranges of lighting, also by Thorn EMI, are introduced using a progression of the face used for their 2D logo, this time placing the headlines inside the shape of a fluorescent strip bulb.

Left, below left, right and far right When an international company is as vast and diverse as Lucas Industries it's not possible to say that any one colour sums up their business character. The Lucas house colour is green for no other reason than that it has always been green, although it has recently been made brighter. The design (by Pentagram UK) of the symbol known as the Lucas diagonal originated in the need for a flexible device suitable for product colour-coding. The special characteristics of the stripe are that it is capable of infinite length, can carry or be reversed out of colour and is able to wrap around three-dimensional objects. The actual configuration was evolved by cutting a right-angled L (for

Lucas) in a stripe and moving the two pieces apart. This converted a plain geometric form into a personalized heraldic motif.

■ Left, far left and below left
The cover and two spreads
designed by Lloyd Northover for
Marconi's new corporate
brochure. The group required a
brochure that would show the
strength and breadth of the whole
company, while emphasizing their
new and, in some cases,
little-known specialist resources.

The solution is highly visual in treatment with each double-page spread devoted to a single subject. Words are kept to a minimum, set against a brightly coloured panel, or reversed out of black. This image of brightness coming out of the dark echoes the radar and ultrasound equipment that the company makes.

Engineering and technology

If banks need to portray friendship and caring, then engineering companies and those involved with high technology must promote themselves as efficient, strong, dynamic and innovative. Their use of colour needs to be bright but not flippant. It could suggest their product base, perhaps — a steel company, for example, could use strong grey/blues to promote its business operation.

■ Above A brochure designed by Richard Mellor of Sutherland Hawes Design, for Perkson Forging. This company melts down metal to manufacture parts for the automotive industry, a process which is reflected in the bright colours used throughout the brochure to symbolize the changes in colour that the metal goes through, from hot yellow to cool blue. The cover of the brochure uses these colours and the company's initials, PF, to create a striking pattern.

Corporate colours

The importance of the right choice of corporate colour can't really be stressed enough, but the logo must be right too. Both must be able to be adapted easily to a range of media which will carry the company's name — from stationery to clothing, shopping bags to shop fronts. The colours and lettering must be distinctive enough to survive the competition from other corporate designs, be readily identifiable in any situation, and still project its own, particular image.

Above and right Colour for recognition - this is the purpose of any corporate communications colour scheme. British Telecom, the main British telephone company, uses two colours: the dominant colour is bright yellow, seen in every British high street on countless service vehicles; the typography and logo is used prominently in blue, the 'digital' appearance of the type conveying the sense of high technology. For some literature the colour scheme is reversed, with yellow set out of a blue background. These colours are infinitely adaptable to any carrier of the corporate message. As the brochures above show, the corporate yellow is strong and stands out well at the head of the design.

Recorded Music

YEAR ENDESS SECREMEN MITHOUSANDER		Chekenho Pucose
10/00	8 912,260	\$112.715
	817.575	89.604
reeo	765.933	60.724
	752.317	59.656
THE COLUMN TWO IS NOT THE OWNER.	811.287	85.014

off in 1986. When combined with fewer new store openings the most ket for nadeo software will become more selective with his motion postules provising an increasing share of recenture. Witness Brus' tevent examples of bourteast record

In 1885, WHY released by most platness certified by each in access of 1803/281 ment heaters thin rules with ordiners. Therefore the release the release the second of the respective part black feature. Therefore, the feature of the feature of the feature of the release t

in an effect to infimiliate consumer valve of integer bleves where WHV has beginn to other special thematic presence, one and infimiatival technical prison. Early in 1996, separate groups of similar and westerns will be respected to a limited similar assignment line and westerns will be respected to a limited similar assignment line prison of \$24.98 and \$29.98 respectively.

With 8 international reteriors were marginally improved in 1983 as a transfer of popular theatrical ritles generated subscanthat also will be trade convenient to grant of one a great warmen, after a college trade of a great mark convenient, amounts of the college trade of a great college trade of the college trade of the distribution of a substantial college trade of the distribution of a substantial college trade of the distribution of a college trade of the distribution of the distri

Charles of Contract of America III. A reported improved operating of the second field in part to supplicate a during the search.

The Allower the endition and misses, Extension, Johnson and other order that a control one behind that the Allower though the at control one behind that the Allower though the Allower through the Allower th

Fro the W. I. Besendol, Mining desiron, 1998, ware a pair of congruent in the symmetr. Reviewers of 49(2.4) millions instrumed [2]—over 1994 by also and opporation movemed 43(12.7) millions in to the best on the decisions between the forces 1994 by strong models and 22.7 over 1978 by previous high of \$2.6 million. The [1978].

The first country of the control of

The W.I.He, and the trough three dominists labels—Warner Ben., Assume a soil I beheal Assum—pollectivels contentioned the recorded mass, inclusively in 1983, with all-time high sales. But a west notable performances throughout the group in 1983. With the number one titles on Billboard I pop alloam. shart. Warmer lists, Records' doments, silve excerded those of Vols, the lever tear on houses. A man contrastiveness Warmer lists, excellent results was Maderias's Lev A Vergo, which, some no vision ex Normeth, 1994, has sold see million resolution for the contrastive tear and the artists interested in the U.S. and another for emitted units interestationally. Attent in Results' stronger reson and extraining general see helplaying the site suggested to the contrastive tear of the contrastive in Results' stronger reson and extraining general see the problematic able of most their seven million units. Moster Card Theories of least, as who would have be approximate the re-

W.L. International keratings were up 65% in 1991, that to uniterest reso, exclude friences from immentional and local recording attentibility. Witner Eine, Music also restablished new resords for recensary and operating income as a benefined transcriptional engineering in performance resistants. The dissensity performance, as well as opposition for future growth, can be arrived to far number of factors.

WCFs recorded music sales were characterized more than ever by their broad-based nature. In 1985, strong results we when ad across a wade spectrum of musical styles with both

Above and right Annual report cover and double-page spreads for the international company Aidcom. It is a worldwide group of interrelated consultancies specializing in market research, design and new product developments. The design is formal and serious.

Above and right The cover and a double-page spread from the 1985 Annual Report for Warner Communications, designed by Pentagram. Appropriately, for a company involved in films and music recording, the cover is avant-garde, vibrant and entertaining. The script face on

the cover and the text spread shows a healthy disregard for formality. The layout of the text spread is clean but striking and good use has been made of contrasting serif and sans serif faces. The solid yellow tint works well as an eye-catcher.

F ollow the yellow brick road

■ Below Two simple examples of colour use to separate, or pin-point, particular items within the design or text. On the left the various sections of the magazine contents are made easily visible by the use of coloured subheadings. On the right, coloured tints behind the type separate additional features from the main body copy.

Colour has another role that doesn't rely on its symbolic associations, and this is in the field of information, where its use is as a means of making information clear and legible. In this area the originality of the idea takes second place to the visibility and immediate readability of the message. Because there is such a large range of colours, different hues can be used to make blocks of information distinct from the other information that surrounds them. This function is of tremendous importance in the design of such material as timetables, annual reports, forms, calendards, sign systems and maps.

Most work of this nature can be read and understood to only a small degree when produced in black and white, because the greater the complexity of columns and facts, the harder it is for people to find their way around what they are looking at and comprehend it. But by including coloured rules to separate vertical and/or horizontal columns, or coloured tints behind selected areas, or by marking out particular items in colour, the designer can reduce these problems. Colour distinctions are extremely helpful when signs are read from a distance, as are the road signs on a highway that distinguish between minor roads and highways.

I find that the best way to approach complex problems of tabular design is first to conceive the initial concept in monochromatic terms and then

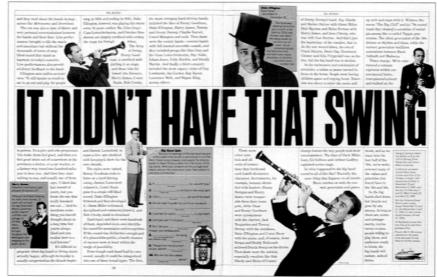

to introduce secondary elements and colors. It is far easier to assess illegibility objectively in monochrome and then to add other colours one by one to resolve areas of poor legibility and clarity.

Another form of colour 'signposting' concerns shop signs. This extremely important visual element informs shoppers immediately of where to purchase their desired commodity. This is particularly important for large chain stores, such as Safeway, Marks and Spencer and Woolworth. They know that as customers move around from town to town, city to city, country to country, on business or holiday, they must be able to pick out their favourite store from the inevitable sea of neon, display and billboards that surrounds any busy shopping area. The corporate colour schemes are often designed to be bright for just this purpose.

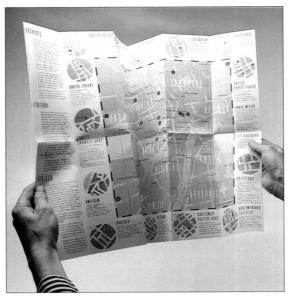

■ Left and below Maps and timetables are areas where efficient and well-planned colour-coding is essential. Complex timetables must communicate information quickly and clearly to travelers, who are often short of time as they seek their next destination, time and terminal.

33	3	a								
km	km	treinnummer		5517	5815 2913				1817	
0 4 14 23 23 29 36 45		Amsterdam CS Amsterdam MP Weesp Naarden-Bussum Bussum Zuid Hilversum Baarn Amersfoort	V	0	5 19	5 39 5 46 5 54 5 57 6 02 6 08 • 6 16			%~~~~%	6 03 6 08 6 15 6 22 6 24 6 30 6 36 6 43
		treinnummer			315	1615	œ	17		5617
	0 3 9 12 16 21	Utrecht CS Utrecht Overvecht Bilthoven Den Dolder Soestduinen Amersfoort	V		5 50	5 56 5 59 6 04 6 07 6 11 6 16	3	6 23	3	6 26 6 29 6 34 6 37 6 41 6 46
		treinnummer		3		{	3	1		1817
45 56 63 68 72 78 84 93 102 111	21 32 39 44 48 54 60 69 78 87	Amersfoort Nijkerk Putten Ermelo Harderwijk Hulshorst Nunspeet 't Harde Wezep Zwolle	V		6 08	6 18 6 26 6 31 6 35 6 40 6 47 6 53 7 00 7 07		639	××	6 49 6 56 7 01 7 05 7 10 7 15 7 19 7 25 7 32 7 39

maandags en op 27 dec., 2 jan.,

6 45 9 04 10 33 11 30 12 29 13 30 14 25 16 04	7 45 10 09 11 45 12 45 13 46 14 50 16a00 17a55	9 25 11 46 13 31 14 43 15 55 17 02 18 08 20 13	10 05 12 26 14 00 15 01 16 04 17 06 17 54 19 58	TEE 13 20 15 39 17 07 18 02 19 00 19 59 20 49 22 25	14 30 16 52 18 40 19 40 20 39 21 43 22 36 0 15	17 00 19 21 20 51 21 49 22 55 0 07	PARIS-Bare de Lyon *	30 6/12 1 10 0 02 22 52 21 48 20 50 18 41	27 6 26 3 18 1 20 22 55 21 42 20 44 18 24	7 27 3 57 0 08 22 10 20 46 19 22 18 23 16 20	28 7 45 4 29 23 59 22 30 21 02 18 50	26 8 27 5 24 3 24 23\30 22 48 20 45	8 30 5 27 3 31 23 53 23 02 21 05	13 30 11 07 9 26 8 14 7 05 6 00 4 4
TEE 17 37 21 21 22 15 23 13 0 10	20 42 23 47 5 15 6 10 8 07	26 20 45 23 50 1 48 5032 6 15 8 20 37. Nice	0 09 1 44 4c35 5c51 6 57 9 07	27 21 46 2 43 5 03 6 20 7 23 9 40 certain	28 22 30 1 42 6 10 7 45 8 40 10 27 s jours.	29 22457 2 25 4 15 6 30 7 48 8 40 10 27	PARIS-Bare de Lyon* DIJON* LYON-Perrache* VALENCE* AVIGNON* MARSEILLE* TOULON* NICE	7 TEE 13 44 9 58 9 03 8 07 7 10 6 01 d) Paris-		an at year	8 50	19 18 17 48 16 45 15 45 14 41 13 50 12 07	TEE 22 16 19 56 18 30 17 34 16 35 15 35 14 49 13 15	123 3 21 1 119 4 118 5 117 5 116 5 13 3
(b) Mar	seille Bla	07, Mar	seille 4 I	37, cer	13 44	15 17	MARSEILLE*	e) Arriv	7 43 6 54	8 45 8 04	9 28 8 48	11 45	13 12	13 5 13 1
6 00	7 10	8 40 10 27	10 06	11 33 13 37	14 25 16 04	16 00 1 17 55	TOULON*			6 15	7 10	9 04	10 20	11 4
6 00 6 40 8 36	9 17	-		TEE 20 11	21 57 22 36	0 15	MARSEILLE*	15 28 14 49	19 05 18 23 16 20	20 15 19 36	21 42 21 02	22 39 21 55	23 26 22 43	23 5
6 40 8 36 TEE 16 50 17 28	9 17 17 14 17 54 19 58	18 30 19 18	19 25 20 06 22 17	20 49 22 25	0 15	4	NICE	H 13 15	16 20	18 00	18 50	19 56	20 30	21 1

²⁴ april en 1 mei

Utrecht CS A 5 43
(via Breukelen, zie tabel 30a)

Right and far right Strangers to larger cities always have problems finding their way around. Street and highway signs therefore need to inform quickly and efficiently; colour-coding needs to be clear and consistent, and typefaces need to be legible. The most efficient typeface chosen for directional signs is the basic sans serif (Helvetica, with its simple, clear-cut lines is the most common). Just imagine how confusing life would be if all signs were in black and white!

Above and right Sections of folds from a broadsheet which promotes a 'Modern Sign System' (logo above) for the HB sign company. Starting at the A5 Entrance the broadsheet unfolds as you follow the arrows through a series of colourful instructions to reveal the final A4 message that promotes the product.

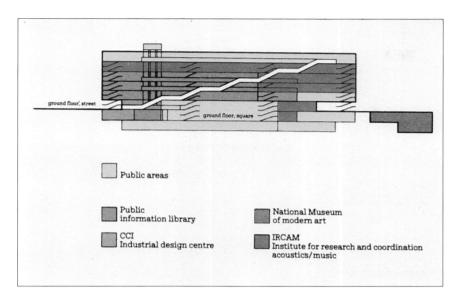

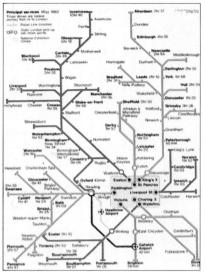

Above and right Further examples of informative colour-coding. These extracts from a leaflet explain the various levels and areas within the Georges Pompidou Centre in Paris.

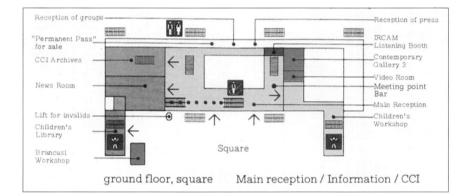

Above A simple, easilyunderstood colour-coded design which explains the major express routes of the British Rail system.

■ Left In order to achieve consistency of colour-coding for their vast range of products, Lucas Industries produced a series of manuals to explain the correct implementation of colours for each of their products.

A ny colour will do

This is where designers can let their hair down. Gone are the restrictions of having to consider product association, socio-economic groups, value, image, mood, etc. Here colour can be pure self-indulgence. If it looks right, it is right, the only rules being those of your own aesthetic criteria. However this freedom itself can pose problems. Many designers find it a bigger handicap than being presented with a tightly controlled brief dictated by detailed market research. These next four pages illustrate varaious examples of free creativity. Although there has ultimately been a client to satisfy, the main feature of these examples is their obvious freedom of expression.

Right A fun design from Tim Girvin Design using words painted in free brush script in lively colours to represent the bunch of flowers.

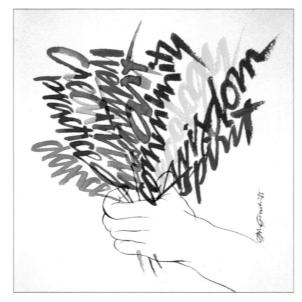

Crillee Bold Ita lee Extra Bold I abcdefghijkimnopqrstuvwxyz æøð &7£\$%(_);;;;;= ABCDEFGHUKLMNOPQRSTUVWXYZ ÆØ 1234567890 abcdefghijkimnopgrstuvwxyz æell &?!E\$%....\inj\::-----ABCDEFGHIJKLMNOPGRSTUVWXYZ ÆEI 1234567890 El al Eal Eal Eal abcdefghijklmnopqrstuvwxyz æafi &?!E\$%(,;;);;;/;:ABCDEFGHIJKLMNOPQRSTUVWXYZ ÆD 1234567890 El al Eal Eal Eal abcdefghijklmnopqrstuvwxyz æn6 &?!£\$%(...) **//-**
ABCDEFGHIJKLMNOPQRSTUVWXYZ Æ11234557890 El al Eal Eal

Machove A very colourful design by Lloyd Northover for the promotion of Crillee – a new typeface in the Letraset range of instant lettering. They have cheated a little, as the typeface is spelt with a C, not a K, but the design is still fun.

Left These designs by Lloyd Northover, also for the Letraset company, are extracts from a brochure created to promote the Pantone range of colours and products.

Right A spread by the designers Grundy Northedge which makes very good use of white space and spots of colour.

Above The 1987 catalogue cover for Quarto, a publishing company, designed by QDOS. The colour is restrained with just an occasional touch of bright colour here and there.

Cleveland Opera Theater #1983 Flenth Anniversary Season-

Above What a lovely piece of design. Both self-indulgent and functional, it contrasts the fine calligraphy of Georgia Deaver against the tasteful illustration of the flowers.

- Left As mentioned previously, television provides designers with marvellous opportunities for colourful and adventurous typography. This is a fine example of such a titlepiece, by Glazer & Kalayjian, for Katz Sports.
- Above These banners, marking 42nd Street in New York, could have been designed in any colours, but none are as striking as the primaries – red, yellow and blue.

■ Above Coley Porter Bell designed this decorative logo as part of a scheme to promote an in-store range of footwear by Yoyo. Moving well away from what could be termed conventional colours they have used two unusual but successful colour combinations.

■ Right Colour has been used functionally in this layout to identify blocks of text, but it is decorative in the sense that the choice of colours was arbitrary. However, I think the use of colour here lacks any subtlety and borders on the crude.

Above T-shirts now form a very important area of promotion and the typographer can go to town on these designs. If the clothes you wear are a personal statement about yourself this is taking your statements one stage further.

Right Clothing labels have become decorative rather than being merely a means of identifying the manufacturer's design. Wrangler and Levi are aware of this fact but now other designers are catching on. I find this 'Disciples' clothing label by Worthington well designed and a delight to look at.

■ Below A hand-lettered book jacket design by typographer David Gatti, for Holt Rinehart. It is both decorative and tasteful, and uses the intricate character combinations well.

■ Above A'logo design by Vaughn Wedeen Creative, Inc. for the 'Inn on the Alameda.' The mirrored cap A contributes well to the decorative nature of this flat three-colour design.

Above A book jacket design by Gun Larson for the publisher Alfred A Knopf. The excessive space between the L and O in Louise is well solved and adds extra dimensions to the decorative nature of the chosen typeface. On the original, both the line shadow around 'Louise Bogan' and the word 'Elizabeth Frank' are printed in silver, but as the 'Louise Bogan' silver is printed next to orange it takes on a gold appearance, adding extra colour to the final design.

Left A calendar box set by Trickett & Webb. The cover is purely decorative, evoking a Japanese feel which is associated with the contents of the calendar. There is a very clean use of white space on the actual calendar spreads, which draw attention to the dramatic photography. The red and black vertical blocks add a new dimension to what would have been a fairly ordinary calendar page.

Above This attractive and tasteful series of cards for Opéra Photographic, designed by Martin Butler, takes its design from collage. The letters look as if they are made from torn paper and cut-outs. The colours chosen are perhaps a little too subtle for a photographic company.

S quare pegs in round holes

For anyone wishing to become a 'professional' professional designer it is certainly necessary that he or she has a working knowledge of type and copyfitting. It is the designer's responsibility to discover in advance whether or not there will be copyfitting problems, and if so, to what extent. With a prior knowledge of such problems the designer has the opportunity of offering a range of solutions and implementing the most appropriate answer to put matters right.

Those who work regularly with copyfitting problems are often required to fit a great deal of copy around all manner of shapes. In fact most typographers relish the challenge of complicated run-arounds (copyfitting around irregular shapes). There is a great deal of pleasure in fitting square pegs into round holes, especially when it works the first time — if only it would more often! But when faced with a mass of copy and illustrative matter where does the typographer start?

There are two interrelated aspects of any design problem, including the text, that need to be discussed and resolved prior to commencement of the work. Simply, they are whether or not to:

- (i) design to the supplied copy or,
- (ii) write copy to fit the design.

Which actually comes first, design or copy, does not really matter. The answer will depend more on the nature of the job in hand. For example, technical literature will always require a certain amount of copy, regardless of what the designer may wish. This suggests that the copy take prefer-

ence over design, which will be created appropriate to the text. Conversely, a simple ad with a crisp snappy headline can often be designed first, followed by a request from the designer to the copywriter for x number of words to complement the layout.

There is more than one method of fitting copy into a particular space, and each typographer has his or her own particular favourite. When complicated run-arounds are involved, my own preference is to estimate the type size and line feed, have the type set from the galley proofs, produce an accurate tracing of the space allotted to the copy showing the appropriate line breaks, and then have the whole job re-run to fit. It might sound a rather lengthy process, but it does give the typographer total control, although on smaller jobs it can be quicker to work straight from type specimen sheets and trace each word in position on a master layout for the typesetter to follow.

The complex problems of run-around type may now be solvable by the computer, but the use of such equipment is expensive and it can be cheaper to rely on the traditional methods. I mentioned above that my own preference is to order a galley proof of the copy and then to make an accurate tracing indicating the copy run-around. This method does work well, particularly for large jobs, and it makes it reasonably easy to calculate the size and line feed of your type.

The copy should be typed on a standard elite typewriter, and the layout drawn in marker pen to indicate quite clearly where the copy, illustrations and photographs should be positioned. The appropriate transparencies and illustrations should be included so that accurate position and proportions can be calculated for both typesetting and artwork purposes.

First, draw up accurately on a sheet of tracing paper the page size and any internal margins or columns designated by the designer.

Having completed this, mark out the position of the illustrations. You will probably have to trace them up using a visualizing camera, or Grant

Left The elements of copyfitting: a rough layout with a type mark-up, the type indicated in lines of black felt-tip; a rough layout with the colour mark-up; the first galley of set text; and the artwork for the main heading, in bromide.

camera. This gives you the opportunity of assessing the best proportions and crop for the illustrations. When producing a working tracing for other artists and designers to progress further, try to use a *black* felt-tip pen to indicate the copy, *blue* for the position of artwork and *red* for typographic instructions.

COUNTING THE CHARACTERS

Now to estimate a suitable size for the type. First produce an accurate character count for each paragraph from your supplied copy. The quickest method, assuming that you have correctly prepared typewritten copy, is with the aid of a standard inch rule. Most typewriters produce either 10 or 12 characters to the inch, so simply measure the length of the average line length, multiply the number of inches by 10 or 12 and then by

■ Right The amount of characters in a line can be estimated by counting the numbers of characters in an inch, and multiplying them by the number of inches in the line of type.

Right The number of characters in a line of set type can also be calculated by referring to the type specimen book. Measure the length of your set line, multiply it by 29 and divide it by the length of the lower case alphabet on your alphabet sheet.

the number of lines in each paragraph.

Copyfitting tables are available for most typefaces, but there is a much simpler method, which only requires your typesetter's sample alphabet sheets and a small pocket calculator. I must point out that it is very important that your reference sheet is supplied by your chosen typesetter; machines do vary, and typeface design can change quite considerably from one manufacturer to another. The wrong spec sheet can easily cause inaccuracies when casting off.

From your specimen sheet assess the size you feel appropriate and measure the length of its lower case alphabet and apply it to this simple equation.

Why the figure 29? Although there are 26 characters in the English alphabet the letters m and w occur infrequently, whereas small unit characters such as i, l and t occur with greater frequency, therefore the figure of 29 is more accurate. That figure can be reduced if your copy contains an above average quantity of caps and numerals. It's the simplicity of this method that allows the typographer greater flexibility than would normally be found with conventional tables. The beauty of this fraction is that it will work in any unit of measurement, unlike copyfitting tables.

Once you have calculated the number of characters per line it is a simple matter of maths to calculate the number of set lines per paragraph. If the copy falls well short or well over simply repeat the exercise with a different size. With experience you'll find that you will assess the correct size first time with increasing regularity.

WORKING OUT A RUN-AROUND

First, work out a specific measure for your galley, preferably a width unaffected by the run-around. If the shape is totally free, without any specific measure, you will find it easier to have the galley set to the longest line and work from that. You then need to estimate the area available for text. Working from your chosen measure, calculate the depth that the type area would fill if it were not an irregular shape but a conventional rectangle. This is quite easy to work out. Once you have estimated a proportionately equal rectangular area of copy, work out your type size. This is the size of type you

DEPTH FOR CALCULATION Z

■ Above To arrive at a rectangle in order to work out your type size in an irregular shape, construct, by eye, a rectangle (y), in which b is equal to the area of a. The resulting rectangle z, which consists of c and a, will be equal in area to c and b, and will be the rectangle you use to calculate your type size.

require to fit your run-around; you are now ready to order your galley proof.

To save both time and money, work directly from a first proof; there is no need for your type-setter to correct any keyboard errors at this stage (although they should be marked on the proof), because corrections can be made when the job is re-keyed for the new line endings of the run-around. Having received your galley, simply trace the type, working the copy around the various shapes of the illustration areas until, ideally, you run out of both space and copy simultaneously. If the copy falls a bit short, try re-working the

■ Left An alternative to tracing the type from the galley around the illustration shapes is to cut up each line of text and fit it around the shapes. You might do this if you were going to show the layout to the client.

■ Left The reworked galley has been returned to the typesetter and has now been set as a runaround. It is ready to be pasted down as camera-ready artwork.

type with a little extra line feed. This is quite easily assessed with a standard type scale. If the copy falls well under or over, don't panic. Estimate visually the size you think would fit, then reduce or enlarge your proof to your assessed type size with a PMT machine. Make a print and repeat the exercise. If you do not have a repro camera you can re-trace the copy directly from your Grant camera. It's not ideal but it will produce the results you need.

You'll be surprised at how proficient you become with experience, but beware! No matter how long you've been copyfitting there will always be the occasional job that, because of unfortunate word lengths and wordbreaks, just won't fit. When this does occur, see if it is possible for the copywriter to re-phrase some of the text, or ask if the art director is prepared to accept modifications to the proportions and crops of the illustrative matter.

Good graphic design is about teamwork. In the final analysis it is the visual appearance of the finished work that counts.

If your layout contains greater flexibility than the example I've just illustrated, you can avoid much of the tracing work I've described. For example, if your design starts with a run-around and then standardizes to a uniform measure, the copy mark-up can be handled quite simply. Calculate the type size by the method described in the previous example. Then, on your layout, rule where you wish each line of type to be positioned, base line to base line, leaving a uniform gap between the end of each line and the illustration. Measure each line in millimetres, (the millimetre is a much easier unit to work with than the em for width measurement — all modern typesetters can work in metric units) neatly marking the line

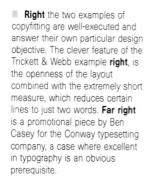

Typographers love the challenge that this type of layout provides and in this instance the designers Jonson Pederson Hinrichs and Shakery have handled the problem with fine skill and judgement. The introduction of the small Christmas trees to denote paragraph endings is first. a nice visual touch, and second, a clever trick to simplify the wrap-around problems. For example, to the right of the boot the word 'weapon' ends a paragraph. If the tree device were not used the single word would be left as an orphan at the head of the column which would have been totally unacceptable.

length of each line on the tracing. The typesetter can then set each line to your given measure, creating the run-around effect you require.

You can of course use this method for more complex work, but it can be expensive if it doesn't work the first time. Generally speaking, keyboard time is charged at a far higher rate than that for typographers and artists. This is necessary to cover the high capital investment of typesetting equipment.

WORKING FROM A GRID

For general brochure and leaflet work the starting point for most designers is the formation of a basic grid structure. The grid may be an ideal starting point for most problems, but if it is implemented too rigidly it can cause more problems than it solves. For instance, if the grid structure deems it necessary to preserve a rigid format on each page with illustrative matter of a fixed size and position, it has to be appreciated that there is little freedom to meet a client's demand for that 'extra' paragraph to be crammed into the text. Within any basic grid structure it is always good practice to build flexibility into your design. Allow yourself the freedom to vary the crop and proportions of your illustrations, and don't forget white space. The inexperienced designer - and certainly the client - is more often than not afraid of white space. Used intelligently, white space will always allow the design to breathe, be fresh, and most important of all, improve legibility. Within the most basic of grid structures it's surprising how much flexibility can be built into the structure.

So far I've stressed the importance of flexibility within the layout, the intelligent use of white space

and the advantages of allowing designs to breathe freely. The possibility of space and flexibility within a design brief is not always available to the typographer. Although good designers and typographers always have in mind the objectives of fresh, readable layouts, how do they achieve such objectives when faced with the large amounts of text required to fit within the tight restrictions of magazine and newspaper layout, for example? The

main concern is nearly always to fit the maximum amount of copy into the minimum amount of space — achieved, sadly, at the expense of design and legibility. But this doesn't necessarily have to be the case.

I hope that some of the tips and examples within this appendix will help with possible problems of copyfitting and enable you to bring your own and other designers' ideas to fruition.

Right This design has become a standard style of layout for upmarket fashion magazines. The photographer was Gilles Bensimon.

Interesting and complex run-arounds are quite common in advertising layout. Here are just two examples. The design on the left comes from the Lowe Howard-Spink Campbell-Ewald Agency. Art-directed by Alan Waldie, the excellent typography is by Brian Hill. The example below was designed by David Garcia for B.B. Needham Worldwide. It looks simple but a lot of well-earned experience has gone into that design to produce such a balanced resolution.

G lossary

When you're compiling a glossary, the difficulty is not in knowing where to begin, but where to stop. I've tried to restrict this glossary to typographic terms and to terms that the typographer is likely to encounter while dealing with typesetters, artists and designers. Italic type indicates that the word or term has its own glossary entry.

A

AA Abbreviation of 'Author's Alteration', used to identify any alteration in the text or illustrative matter that is not a printer's error.

Accent A mark added to a letter in certain languages to indicate a change in pronunciation, stress, etc., e.g. acute é, cedilla ç or grave è.

Addendum Matter to be included in a book after the body copy has been set, which is printed separately at the beginning or end of the text.

Advertising rule Rule used to separate one magazine or press advertisement from another.

Align To arrange letters and words on the same horizontal or vertical line.

Alphabet Length Horizontal measurement, in points, of the length of the *lower case* alphabet.

Alphanumeric Contraction of 'alphabetic' and 'numerical' referring to any system that combines letters and numbers.

Ampersand The symbol '&', used as an abbreviation for the word 'and'.

Annotation Labels, captions or numbers, used on illustrative work.

Arabic numerals Numerals from 1 through to 9 and zero (as opposed to Roman numerals), so called because they originated in Arabia.

Arm Horizontal stroke of the characters E and F, which is free on one end. **Artwork** All original copy, whether

prepared by an artist, camera, or other mechanical means. Loosely speaking, it is any copy to be reproduced.

Ascender That part of the lower case letters b, d, f, h, k, l, and t which rises above the *x-height*.

Asterisk The symbol *; usually used to indicate a footnote or to give special emphasis.

Author's alterations See AA Author's proof Marked proofs with typographical errors corrected by the typesetter. The author reads them and makes any necessary alterations.

\mathbf{B}

Backslant Typeface which slants backwards, i.e. opposite to *italic*, which slopes forwards. The effect can be obtained by many headline machines and *computer typesetters*. Bad break Incorrect end-of-line hyphenation, or a page beginning with either a *widow* or the end of a hyphenated word.

Bad copy Any manuscript that is illegible, improperly edited, or otherwise unsatisfactory to the *typesetter*. Most typesetters charge extra for setting from bad copy.

Banner Main headline across the full width of the page.

Bar Horizontal stroke in the letters A, H, e, t and similar characters.

Base line Imaginary line on which the base of a line of type (excluding *descenders*) rests. Bastard size Non-standard size of any material used in graphic design.

Black letter Script with angular outlines developed in Germany, which superseded the lighter *Roman* in the 12th century. The term is also applied to types developed from it, such as *Fraktur*, *Gothic*, and *Old English*. Blad Sample pages of a book produced in booklet form for promotional purposes. Bleed Area of plate or print that extends

(bleeds off) beyond the edge of the trimmed sheet. Applies mostly to photographs and areas of colour.

Blue line Blue, non-reproduceable line, printed or drawn by the artist on artwork as a layout guide for the position of typesetting, artwork, etc. Because the lines are blue they do not show when photographed for platemaking.

Body The shank of the type.

Body size Overall depth of the body of a piece of type measured in *points* or millimetres.

Body text Also called body matter. Regular reading matter, or text, as opposed to *display* or *headline* matter.

Body type Also called *text* type. Ranging normally from 6pt to 14pt, it is generally used for text matter.

Boldface Type of a bold, heavy appearance. Normally a bolder version of the standard weight of type.

Book face Weight of typeface suitable for large areas of text.

Border continuous design arranged around text or illustration

Bowl Curved stroke that makes an enclosed space within a character. The bump of a P is a bowl.

Box Item ruled off on all four sides usually with a heavy rule or border.

Brace Sign used to group lines or phrases, it appears as].

Brackets Marks used to enclose and identify editor's addition to text or parenthetical material within other material already in parentheses [].

Break for colour To indicate or separate the parts of camera-ready artwork (also known as a *mechanical*) for colour printing.

Break in copy Term indicating that part of the copy that is missing.

Breakline Short line, usually at the end of a paragraph.

Brochure Pamphlet or other unbound short work with stitched or stapled pages.

Built fraction Fraction that is made up from two or more characters. For example, 7/8

would be made from a 7 followed by a / followed by an 8, as opposed to a *piece* fraction.

Bullet Dot of any size, used as an ornamental or organizational device.

C

Calligraphy Term comes from the Greek words *kalli* and *graphos*, meaning 'beautiful writing'. A calligrapher is a person who writes in an elegant traditional style, usually with a calligraphy pen, and sometimes with a brush.

Cap Abbreviation for capital letter.
Cap height Height of a capital letter from its base line to the top of the character.
Capital letters, capitals Name of the upper case letters. It derives from the inscriptional letters at the head, or capital, of Roman columns.

Cap-line Imaginary line that runs along the top of the capital letters.

Caps-and-smalls Type set with most or all the initial letters in capitals, and other letters in small caps instead of lower case. Caption Strictly speaking, the caption is the matter printed as a headline. It is usual, however, to refer to descriptive matter printed underneath an illustration as a caption.

Caret The symbol , used in proof correction to indicate an insertion.

Carolingian script A 9th-century script developed for the Emperor Charlemagne's revision of grammars, Bibles, church books, etc.

Carry forward To transfer text to the next column or page.

Case fraction Small fractions that can be made up as a single character, e.g. $\frac{1}{8}$. Cast-off Calculation of how much space a given amount of copy will take in a given type size and measure.

Cast-up Calculation by the printer of the cost of typesetting.

Centred Type placed in the centre of a sheet or type measure.

Centre dot The centre dot is used, among other things, to indicate syllabications. It can be of any size and is usually centred on the lower case *x*-height of the typeface. When used with caps it should be centred in the middle of the *cap*-height.

Centre spread Centre design of a brochure or magazine covering both pages.

Central processing unit (CPU) Section of the computer that controls interpretation and execution of instructions.

Chapter heads Chapter title and/or number of the opening page of each chapter.

Character Any single unit of a type fount, whether it be a letter, numeral or punctuation mark (or space, when calculating a character count).

Character count Calculation of the number of characters in a piece of copy.

Character set Width of each character Cicero Continental equivalent of the *pica*, but fractionally larger. Used as a unit for measuring the width or measure of a line of type and the depth of a page. One Cicero — about 4.5mm, or 12 *Didot points*.

Clean proof Typesetter's proof free from errors.

Close matter Solid type, set with very few breaks.

Close spacing Type set with very little space between the words.

Close-up Instruction meaning to delete a space, i.e. bring the characters together.
Club line Short line coming at the end of a paragraph; should not occur at the top of a page or column.

Colophon Inscription formerly placed at the end of a book giving the title, printer's name, and place and date of printing. It also refers to a publisher's decorative device.

Column inch Publication measurement based on a space one column wide and one inch deep.

Column rule Light-faced rule used to separate columns.

Combination line and tone Combined

block used to reproduce halftone photographs or illustrations with superimposed line letters, figures, diagrams, etc.

Command Part of a computer instruction that specifies the operation to be performed, i.e. the typeface, size, line length, etc.

Comp See Comprehensive

Compose To set copy in type. This is done by the *typesetter*.

Compositor Also called the *typesetter*. The operator of the computer typesetter.

Comprehensive Often referred to as a *comp*. An accurate layout showing type and illustrations in position, and suitable as a finished presentation.

Computer typesetter Computer-controlled method of setting type.

Condensed face Typeface with an elongated or narrow appearance and with the letters set very close together.

Contact print Photographic print made by direct contact with the negative, as opposed to enlargement or reduction.

Continuous-tone copy Image with a complete range of tones from black to white, e.g. photographs and paintings.
Contraction Shortening of a word by omitting letters other than the first and last.
Copy Matter to be set in type by the typesetter. Can also refer to any matter for reproduction.

Copyfitting See Cast-off.

of a chapter.

Counter Inside area of type, such as the inside of the letter 'O.'

CPS Characters Per Second. Measurement of the output speed of the computer typesetting equipment.

Crop To eliminate part of a photograph or illustration in order that it either fits a given area better or makes a better picture.

Cross-head Sub-section, paragraph heading or numeral printed across the page and often centred in the body of text from which it is separated by one or more lines of space. It usually marks the first subdivision

Cursive Typefaces which resemble handwriting, but without connected letters.

D

Dagger The symbol †; footnote reference mark

Dash The symbol —. A punctuation mark, usually known as an *em dash* or em rule. Deadline Time by which copy must be submitted.

Definition Degree of sharpness in a negative or print.

Delete Instruction to take out. The proofreader's mark looks like this **Descender** That part of the lower case letters g, j, p, q, y, and sometimes J and f, which falls below the *base line*.

Didot point Continental unit of measurement for type, established by the French typefounder, Firmin A. Didot, in 1775. One Didot point — .3759mm 0.0148"; one Anglo/American point equals 0.013837", or .35mm.

Differential spacing Spacing of each character of type according to its individual width.

Digital typesetting Typesetting in which the characters are broken down into a dot formation and set close together to form the actual character.

Diphthong Pair of vowels pronounced as one vowel sound, as in Caesar.

Discretionary hyphen Hyphen that is keyboarded with the copy, and which may or may not be used in the printed matter. **Display** Printed matter given prominence by its size and position. This includes prelims, part and chapter titles, headings, advertisements.

Display type Large typefaces designed for headings, etc. As a general rule sizes above 14pt (3.5mm cap height) are regarded as display sizes but this does apply very much to the context within which the type is used.

Dot leaders Series of dots used to guide the eye from one point to another.

Double column Two columns placed side by side.

Double page spread Two facing pages on which matter is continued directly across as if they were one page.

Drop folios Page numbers printed at the foot of each page.

Dropped letter/initial Initial letter covering more than one line of type.

Dry transfer lettering Form of lettering transferred to the page by burnishing each letter off the back of a sheet. It is frequently used by designers and is available in a wide range of typefaces and sizes.

Dummy Prototype of a proposed book, brochure, leaflet, etc. in the correct format. It may take the form of an accurate *visual* complete with the correct paper and bulk.

\mathbf{E}

Ear Small stroke projecting from the top of the lower case letter g.

Editing Checking copy for factual accuracy, spelling, grammar, and consistency of style before releasing it to the *typesetter*.

Elite Smallest type size produced by a typewriter. It contains 12 characters per inch as compared to the *pica* typewriter letter which has 10.

Ellipses Three dots (...) indicating an omission, often used when omitting copy from quoted matter.

Em Unit of linear measurement. Often wrongly used as an abbreviation for pica em. In a general context it is the square of the type size being set. Its main function is in the specification of indentation for paragraphs, e.g. 'indent paragraphs 2 ems'. Em-dash A long dash the width of an em auad.

Ém leader Horizontal series of dots or dashes, evenly spaced one *em* from centre to centre.

Em-quad/space Space equal to the square of the type body size, e.g. a 12pt quad/space — 12pts x 12pts, an 8pt quad/space — 8pts x 8pts

En A measurement half the width of an *em*. **En-dash** A dash the width of an *en*.

End-of-line decisions See H & J.

En-quad Same depth as the *em* (*body size*) but half the width of the *em*.

En-rule A dash approximately half an em

Even smalls Small caps used without full size capitals.

Exception dictionary Portion of the computer's memory in which exceptional words are stored. Exceptional words are those that do not hyphenate along the normal rules of hyphenation. E.g. inkling would become ink-ling, NOT inkl-ing Expanded/Extended type Wider version of a typeface's standard design.

F

Face Group or family to which any particular type design belongs.
Factor number Copyfitting number given to each composition size and typeface developed by the Monotype Corporation.
The factor number expresses an average size of character.

Family Group of typefaces in a series with common characteristics of design, but with different weights, such as *italic*, bold, condensed, expanded, etc.

Fat face Typeface with extensive contrast between the thin and thick strokes.
Figures Arabic figures e.g. 1 2 3 are most commonly used. Roman figures e.g. I II III are used for prelims, chapter heads, part headings, etc.

Film advance Distance by which the film/paper in the photo unit of the computer is advanced between lines.
Filmsetting Process of using photographic means (on film or paper) to produce typesetting. It has almost totally replaced metal setting.

Finished artwork See *Mechanical*Fine rule A rule of hairline thickness.

First proof Proofs submitted for checking by proofreaders, copy editors, etc.

First revise Proof pulled after errors have been corrected in the first proof.

Fit The space between two or more letters. The fit can be modified by the alteration of the set width.

Flush left/right Type that aligns vertically to the left (or right).

Flush paragraphs Paragraphs in which the first word is not indented but set flush with the vertical line of the text.

Folio Page number.

Follow copy Instruction to the typesetter indicating that the spelling and punctuation of a manuscript are to be followed, even if unorthodox, in preference to the house style.

Font A variation of fount.

Foot Margin at the bottom of a page; also the bottom edge of a book.

Footnote Short explanatory notes, printed at the foot of the page or at the end of a book. **Foreword** Introductory remarks to a work or about its author and not written by the author.

Format General appearance or style of a book including its size, shape, paper quality, typeface and binding.

Founder's type Metal type cast by a type founder for hand composition.

Fount All the characters of a typeface, including punctuation, accents, fractions, etc.

Fraktur German *black letter* typeface believed to have originated in Augsburg in 1510.

Frontispiece Illustration facing the title page of a book.

G

Galley proof First proof from the *typesetter* used for checking printer's errors and for checking size and position against the layout.

Gold blocking The stamping of a design on

a book cover using gold leaf and a heated die or block.

Gothic Another name for *black letter*. **Grid** A measuring guide used by designers to help ensure consistency. The grid shows type widths, picture areas, trim sizes, margins, etc. and is used particularly where the work has more than one page.

Grotesk Name of a sans serif typeface of the 19th century

Gutter The fold or channel running through the centre of a book, brochure, etc.

H

H & J (Hyphenation and Justification)

Ability of the computer to automatically hyphenate and justify lines.

Hairline Thin strokes of a typeface. Hairline rule Thinnest of rules.

Half tone See Continuous-tone copy.

Hanging figures See *Old Style* figures. **Hanging indentation** Indented setting in which the first line of each paragraph is set full-out to the column measure and the remaining lines are indented.

Hanging punctuation Punctuation that hangs outside the measure, so that the righthand side of the column aligns visually. **Heading** Bold or display type used to emphasize copy.

Headline Large type in an advertisement, brochure, leaflet, etc. that draws the reader's attention to the design, enticing the reader to read further.

Headliner Machine able to produce display sizes of type. The operator has visual control over spacing, distortion and size. The type is photographically set, letter by letter.

Head margin White space above the first line on a page.

Holding lines Lines drawn by the designer on the *mechanical* to indicate the extra area to be occupied by a half tone, colour, tint, etc.

Hot-metal setting Typesetting that involves each character being cast in hot molten

metal. Many of the terms still used in modern typesetting dervie from the vocabulary used in this method.

House corrections Alterations made to proofs or script by the publisher or printer, as distinct from those made by the author. House style Style of spelling, punctuation, spacing and typographical layout used in a printing or publishing house to ensure consistent treatment of copy during typesetting.

Hung initial Display letter that is set in the lefthand margin.

Hyphenation & justification See H & J.

I

Illustration General term for any form of drawing, diagram, half tone, or colour image included within a piece of print. Imposition Plan for, and the arrangement of, pages in press form so that they will appear in the correct order when printed, folded and trimmed.

Imprint Name of the printer, publisher, date and place of printing. Required by law if the paper or book is to be published. Indent Positioning of type, usually the first line of a paragraph, at a point within the edge of the lefthand margin

Inferior letters or numerals Small letters or figures usually printed on or below the base line as, for example, in the chemical formula H₂O.

Initial First letter of a body of copy, set in a larger size type for decoration or emphasis. Often used to begin a chapter of a book. See also *Drop* and *Hung* initials.

Initial caps The setting of the first word or phrase of the copy in capitals.

Interline spacing Also called *leading* or line feed.

Italic Letterforms that slope to the right. *Looks like this.*

J

Jacket Paper wrapping in which a book is sold

Jobbing work Small, everyday printing, such as display cards, letterheads, labels, handbills and other printing — as distinct from bookwork.

Justify Act of justifying lines of type to a specific measure, right and left, by equally spacing each word within each line to make it fit the full measure.

K

Kerned letters Part of the letter that projects beyond the *body* or *shank*, thus overlapping an adjacent character. Kerned letters are common in *italic, script*, and *swash* fonts.

Kerning The adjustment of space between characters so that part of one extends over the body of the next. Modern typesetters include kerning programmes as standard for letter spacing. Kerned letters produce uniform letter spacing, which closes up any excessive space encountered between such combinations as LY and Te. See also *Letterfit*. Keyline Outlines on artwork that denote the position of illustrative matter as a guide for the platemaker and printer.

Key size Alternative method of measuring type. Key size calculates the size of type by its *cap height*, unlike the traditional method which measures type by its overall depth. It is an ideal system when mixing type on line, because consistency of cap height is always maintained.

L

Landscape A composition or image with a width greater than its depth.

Large fractions Fractions made up of text-size numbers, as opposed to *lower case* fractions.

Layout Outline or sketch that gives the general visual appearance of the printed page, indicating the relationship between text and illustration.

L.C. (l.c.) Lower case characters of a fount.

Leading (pronounced 'ledding') Strips of metal or brass of varying thickness that were used to space out headings and text in the lines of letterpress printing. The term is also applied to such spacing in computerized typesetting.

Leader Group of dots, periods, dashes or hyphens used to lead the eye across the page. Leader line Line on an image keyed in to

Lead-in First few words in a block of copy set in a different or contrasting weight of typeface.

Leg Bottom diagonal on the upper case and lower case k.

Legend Explanatory material used on charts, diagrams, maps, etc.

Legibility Cumulative effect of printed matter on the human eye.

Letterfit Quality of space between the individual characters. Letterfit should be uniform and allow for good legibility. Advanced *kerning* programmes on modern typesetters achieve excellent letterfit combinations.

Letter space Space between the letters.

Letter spacing Insertion of space between the letters of a word to improve the appearance of a line of type. See also kerning.

Ligature Tied letters in type, such as fi, ff and ffi.

Light face Lighter version of the standard weight of a typeface.

Line drawing Artwork consisting of solid black lines. A drawing without half tones. Line feed The modern and more correct phrase that replaces the term leading (which is now a mis-nomer). Denotes space between each line of type.

Line length See measure.

Line overlay Line work put on an overlay to pre-separate the lines from the half tone or to position different colours. Used in the preparation of artwork for reproduction. **Line spacing** Another term for *leading* or line feed.

Line up When two lines of type, or a line of type and illustration, touch the same imaginary horizontal or vertical line.

Lining figures Numerals the same size as the caps aligning on the base line in any given typeface: 1 2 3 4 5 6 7 8 9 10. As opposed to Old Style, or Hanging, figures.

Link Stroke connecting the top and bottom of a lower case g.

Literal Mistake in setting type which does not involve more than a letter-for-letter correction. It includes wrong *founts* and damaged letters.

Logotype Often referred to as a logo. Character(s) designed as a trademark or company signature.

Loop Lower portion of the *lower case* g. Lower case Small letters in a *fount* of type. Indicated as *l.c.*

M

Machine proof Proof taken from the printing press. Machine proofs provide the final opportunity for the correction of misrakes.

Make-up Assembling the various typographic and artwork elements into page form ready for platemaking.

Manuscript (also called MSS) Literally, a work written by hand. It refers either to a book written before the invention of printing, or to the written or typed work that an author submits for publication.

Margins Blank areas on a printed page, which surround the text and illustrative

Marked proof The proof, usually on galleys, supplied to the author and/or editor for correction. It contains the corrections and queries made by the printer's reader.

Mark-up To mark up is to specify every detail needed for the typesetter to set the copy. The mark-up is copy with relevant

instructions.

Masthead Any design or logotype used as identification by a newspaper or publication.

Matter Either manuscript or copy to be printed, or type that is composed. **Measure** Width of a setting measured in *pica*

Mechanical Preparation of copy to make it camera-ready, with all type and design elements pasted in position. Also contains any necessary instructions regarding the laying of tints, *half tones*, etc.

Metric system European system of decimal measurement. The basic unit for designers is the millimetre (mm) and occasionally the centimetre (cm).

Minus letter spacing Reduction of the normal space allocated between characters. Minus line spacing When the *line feed* depth (the measurement from *base line* to base line) is less than the *body size* of the typeface. Should only be used when *ascenders* and *descenders* do not touch, unless a special effect is required.

Misprint A typographical error. **Mixing** Combination of more than one style of typeface or point size in a word, line or block of copy.

Modern face Term used to describe the type style developed in the late 18th century. A typeface with vertical stress, strong stroke contrast and unbracketed fine serifs.

N

Numerals, Arabic See Arabic Numerals. Numerals, Roman See Roman Numerals.

\mathbf{C}

Oblique *Roman* characters that slope to the right, similar to *italic*, but less *cursive*. **Old Style** 19th-century style based on 16th-century forms, characterized by diagonal stress and sloped, bracketed serifs.

Old style figures Also called *Hanging figures*. Numerals that vary in size, some having ascenders and others descenders: 1 2 3 4 5 6 7 8 9 10. As opposed to *Lining figures*. Open matter Type set with abundant line

spacing or containing many short lines.

Ornaments Type ornaments used to embellish page borders, chapter headings, title pages etc.

Orphan (also called widow) Last word of a paragraph that stands at the top of the following page by itself.

Outline letters Open characters made from solid ones by putting a line on the outside edge of a letter.

Overmatter Text matter to be added to existing artwork. See *Annotation*.

Overrun To transfer one or more words from the end of one line to the start of the next to improve spacing, to 'make' a line, etc.

P

Pamphlet Minor booklet of a few pages. Page proofs Preliminary print for checking against original manuscript and artwork, for correct colour and positioning of tint lays, photographs, etc.

Pagination The numbering of the pages in a book.

Paragraph mark Typographic elements used to direct the eye to the beginning of a paragraph □. Often used when the paragraph is not indented.

Parentheses The symbols () used for punctuation marks or ornament.

Paste-up Positioning of artwork ready for reproduction. See also *Mechanical*. **PE** Abbreviation for 'Printer's error', as opposed to AA.

Peculiars Type characters for non-standard, accent-bearing letters, used when setting certain foreign languages.

Period Punctuation mark indicating the end of a sentence or an abbreviation.

Phototypesetting Also known as

photocomposition. The production of text for printing, by projecting type images onto photographic film or paper.

Photostat Facsimile copy of a document — typed, written, printed or drawn.

Pica (em) Typographic measurement equal to 12pts (approximately 1/6th of an inch or 4.25mm).

Pi characters Special characters not usually included in a type *fount*, such as special ligatures, accented letters, mathematical signs and reference signs. E.g. $\Omega \sum \prod_{i} R_i d_i$

Piece fraction It comes in three styles: *Built*, made up of three separate characters — two text-size numerals separated by a slash (e.g. 3/4); *Case*, which are small-numbered fractions available as a single character (e.g. 3/8); and *Piece*, which are small-numbered fractions made up of three or more elements: numerator, slash or separating rule, and the denominator.

Point Standard unit of typopraphic measurement. The British/American point is equal to .35mm, or O.O1383" (approximately 1/72 of an inch).

Point size Indicated by PT or pt. The overall depth of the typeface including the measure of space above and below the actual letter form.

Portrait A composition or image with a depth greater than its width.

Primary letters Lower case letters without ascenders or descenders, i.e. a c e m n etc. **Proof** Impression obtained from an inked plate, stone, screen, block or type in order to check the progress and accuracy of the work. Also called a pull.

Proofreader Person who reads the type that has been set, checking it for correctness of style, spelling, punctuation, etc.

Proofreader's marks Marks made by the proofreader to indicate alterations and corrections to be made on the proof. These symbols are standard throughout the industry.

Q

Quad To space out the blank portion of a line to its full measure. A *hot metal* term that is now more commonly referred to as *ragged left, ragged right* and *centred*. See *Unjustified type*.

R

Ragged left Text that aligns on the righthand margin only.

Ragged right Text that aligns on the lefthand margin only.

Range Instruction to align the righthand or lefthand edge of a block vertically with the type above or below it. See also *Unjustified type*.

Reader See Proofreader.

Reference mark Symbol used to direct the reader from the text to a footnote or other reference. The common marks are as follows: * Star or asterisk \$ Section † Dagger Parallels \$ Double dagger \$ Paragraph

Register Refers to the correct alignment of pages with the margins in order. Also the correct positioning of one colour on

another in colour printing.

Register marks These are the crosses, triangles and other devices used in colour printing to position the paper correctly.

Reproduction proofs Also called Repro.

High-quality proofs on art paper, which can

be used as artwork.

Rivers Streaks of white spacing in the text, produced when spaces in consecutive lines of type coincide.

Revise Change in instruction that alters the copy in any stage prior to final artwork.

Roman Name often applied to the Latin alphabet as it is used in English and other European languages. Also used to identify vertical type as distinct from *italic*.

Roman numerals Roman letters used as numerals until the 10th century A.D. I, II, III, IV, etc.

Rough A sketch that gives a general idea of the size and position of the various elements of a design.

Rule Line used for a variety of design effects including borders, separating lines and boxes from the text. Rules can also be dotted, dashed or decorative.

Run around Text that fits closely around an

Run Number of copies to be printed.

irregular shape.

Run-in Setting of type without paragraph breaks, or the insertion of new copy without making a new paragraph.

Running head Line of usually small type which repeats a chapter heading at the top

of a page.

Run on Instruction for text to be continous without a new paragraph. A run-on chapter is one that does not begin on a new page.

Running text Also referred to as straight matter, or body text. The text of an article or advertisement as opposed to display type.

S

Sans serif Typeface without *serifs*, usually without stroke contrast.

Script Typeface designed to imitate handwriting.

Serif Small terminal stroke at the end of the main stroke of a letter.

Set Refers to the width of a body of type. Also used as an instruction to a typesetter. **Set close** Describes type set with the minimum of space between the individual characters and words.

Set solid Refers to type set without any extra *line feed*.

Set-width Also called set size, or *set*. The width of each individual character within a *font*. This space, measured in units, can be increased or decreased to adjust the letter spacing.

Shank *Body* of the type.

Shoulder The flat surface on a type above and below the face.

Small capitals Capital letters that are

smaller than the standard and usually aligned with the *x-height* of the typeface, i.e. SMALL CAPITALS.

Solid Type set with no *line feed*.

Spec A specification of the size, *line feed* and face of a body of text, for the typesetter.

Spur Small projection off a main stroke: found on many capital G's.

Square serif Typeface in which the *serifs* are of a similar weight to the main stem, as in the Rockwell, Lubalin and Egyptian typefaces.

S.S. Abbreviation for same size. Also indicated S/S.

Star Typographical *ornament*, also an incorrect name for an asterisk.

Stat See Photostat.

Stem Main heavy vertical element in a letter.

Stet Latin word meaning 'let it stand', written in the margin in proof corrections to cancel a previously marked correction.

Straight matter *Body type* set in straight rectangular columns with little or no typographic variation.

Stress Direction of thickening in a curved stroke.

Stroke Straight or curved line. **Style** See *House Style*.

Subheading Heading for a division of a chapter, paragraph, etc.

Subtitle Phrase, often explanatory, that follows a title of a book.

Superior letters or figures See *Superscript.* **Superscript** Small symbol, numeral or letter that prints above the *x-height* and to the side of another character as in 34. Also called superior letter or figure, particularly when used to refer to a citation source.

Swash letters Italic types with calligraphic flourishes.

T

Tabular work Type matter set in columns. Tail Descender of Q or short diagonal stroke of the R; alternatively the margin at the bottom of a book.

Tail piece Design at the end of a section of a chapter or book.

Terminal End of a stroke not terminated with a serif.

Text Body copy of a page or book, as opposed to headings.

Text type Main *body type*, usually smaller in size than 14pt (3.5mm cap height).

Tint Photomechanical reduction of a solid colour by screening.

Title page Righthand page at the front of a book that bears the title, the names of the author and publisher, and sometimes the place of publication and other relevant information.

Titling Headline type which is only available in capitals.

Transfer type See Dry transfer lettering. Transitional Type forms invented in the mid-18th century, which are neither Old Style nor Modern. They include Fournier and Baskerville.

Transpose To change the order of the letters, words or lines.

Transposition Common typographical error in which the letters are incorrectly placed, i.e. 'tihs' instead of this.

Trim size Final size of a printed work after trimming. When preparing artwork allowance must always be made for trim. **Type** Letters of the alphabet and all the other characters used singly or collectively. Type area Area of the page designated to contain text and illustrative matter.

Type family Range of typeface designs that are variations of one basic style of design. Thus we have Helvetica bold, light, light italic, condensed, etc.

Type mark-up See Mark-up. Typescript Typed manuscript. **Typesetter** Person who sets type, or a shortening of 'computer typesetter'.

Typesetting Copy produced by the typesetter.

Type size There are two different methods of defining type size: by the height of the capital letter (see Key size), and by the typeface's overall depth measured in terms of the metal block on which the type used to sit in hot-metal setting.

Typestyle Variation within a typeface: medium, bold, italic, condensed, etc. **Typographer** Person who designs the typographical layout of a proposed printed work. Also a designer of typefaces. **Typography** The study of type.

U

U & l.c. Abbreviation of upper & lower case. Uncial Hand-drawn book face used by the Romans and early Christians, typified by the heavy, squat form of the rounded O. **Underscore** A rule directly below a line of

Unit Variable measurement based on the division of the em or set size into equal increments.

Unitization Designing the *fount* characters to width groups. The width groups are measured in units and are the basis for the counting mechanism of the computer typesetting equipment. Width units can be based on the em or the set size of the fount. Unit system Counting method first developed by Monotype and now used by some typewriters and all computer typesetting systems to measure, in units, the width of the individual characters and spaces being set. By counting the total accumulated units the computer can determine the measure when the line is ready to be justified, and determine how much space is left for justification. Unit value Fixed unit width of individual

characters.

Unjustified type Lines of type set to different lengths aligning to the left or right. Upper case Capital letters of a typeface i.e.

A, B, C, etc.

\mathbf{V}

Visual See layout.

W

Weight Degree of boldness of a typeface. Most typefaces are designed in light, medium and bold. These are known as the different weights

White space reduction Reduction of space allocated to the characters.

Widow Single word at the end of a paragraph left on a line of its own. Widows can often be avoided by editing or adding extra copy to lengthen the last line. Also the end of a hyphenated word, such as -ing. **Word break** Device of hyphenating a word between syllables so that it can be split into two sections to regulate line length in a text. Word spacing Adding or reducing space between words to complete justification. **Wrong fount** Indication that a letter of the wrong size or *fount* has been set by mistake. It is abbreviated as w.f.

\mathbf{X}

X-height Height of the *lower case* letters without either ascender or descender.

\mathbf{Z}

Zip-a-tone Trade name for a series of screen patterns imprinted on clear sheets. Available in dot, line or stipple form.

Index

Page numbers in italic refer to illustrations and captions.

32

A
advertising, mixing typefaces, 32-3
aggressive colours, 78
Akzidenz-Grotesk, 36
alphabet, development, 14
annotation, 30, 36
Appleton, Bob, 34
Arden, Paul, 37
art promotion, 106-7
The Artist's and Illustrator's Magazine,
ascenders, 11, 15
Avant Garde, 12, 23
Avant Garde Bold, 67
Avant Garde Book, 25
Avant Garde Gothic, 23
Avedon, Richard, 37
В
Baker Signet, 25
balance, 20-1
balloon effects, 22
banking, 110-11
Barcelona Bold, 25
Baskerville, 32
Benguiat, 12
Benguiat Book, 25 Benguiat Medium Condensed, 25
Bensimon, Gilles, 132
Berthold, 36
billboards, mixing typefaces, 34
black on white type, 56-9
Bodoni, 24, 61
bold, emphasis with, 53
Bookman, 56, 58
Boots, 85, 87, 93
box perspective, 22
Bridgewater (Peter) Associates, 91
Brimacombe, John, 98
Brown Design, 67
Brush Script, 25
Butler, Martin, 125
C
calligraphy, 14-16
cap height, 10, 11
capital letters, emphasis with, 52
captions, 30, 36
Caslon, 24, 26
Cawsey, Ben, 130
Caxton Light, 40-3
Century, 13, 13, 26, 32, 32
Century Nova, 33
Century Old Style Bold, 52
Century School Book, 24, 50
character counts, 128-9

Clarendon Medium, 28 Clarks, 102 clothing, 102-3 labels, 124
Cogent Elliott, 47 Cogent left, 46, 47 Coley Porter Bell, 28, 82, 87, 95, 96, 99 123 colour:
aggressive, 78 conversion to black and white, 73 cool, 80-1 dominant, 78, 78
excitement value, 79 exciting, 90-2 feminine, 82-3 fresh, 84-5
healthy, 87-8 information communication, 116-19 masculine, 93-4 quiet, 78
readability and, 60-3 sophisticated, 94-5 symbolic properties, 81 vibrant, 88-9
volume, 78 warm, 80-1 colour blindness, 70-3 colour-coding, 116-19
colour temperature, 80-1 Compugraphic, 36 computer typesetting, 20, 21 Congress, 56, 58
connecting scripts, 25, 27 converging perspective, 22 Conway, 130 cool colours, 80-1
Cooperative Health Care Plan, 83 Cope Woollcombe & Partners, 95, 112 copyfitting, 126-33 character counts, 128-9
grids, 131-2 run-arounds, 126, 129-31 corporate identity: colour and, 114-15, 117
mixing typefaces, 34 counter, 11 counter shapes, 16 counting characters, 128-9
Crillee, 120 Crucial Design, 67 Cushing Medium, 25 D
Davies, David, 81, 82, 87, 92 Deaver, Georgia, 15, 122 descender, 11, 15 dip-arch movement, 22
distortion, 20-2, 22 dominant colours, 78, 78 Doyle Dane Bernbach, 133 drink, 98-9

dry transfer letters, 16, <i>16</i> E
Egyptian, 25 Elle, 108, 132
em, 40
emphasis setting, 52-5
engineering, 112-13
English Script, 25, 27
entertainment promotion, 106-7
Ernst, Max, 107
Europa Grotesk, 36
Everley, Ed, 47
excitement value, 79
exciting colours, 90-2
F
Farber, Bob, 12, 12, 13, 13
feminine colours, 82-3
Fenice Bold, 50
Fenice Light, 57
Fenice Ultra Light, 25
finance, 100-11
Fisher, Ling and Bennion, 100
Fitch, 85, 88, 90
food and drink, 78, 98-9
Foote, Cone & Belding, 18
Fordsham, Simha, 52
fresh colours, 84-5
Frieda, John, 28
Fritz Quadra, 17
Frutiger, 17, 67
Futura, 25
G
Galliard Bold, 25
Galliard Roman, 25
Galliard Ultra Italic, 25
Garamond, 24, 32
Gatti, David, 124
Geddes, Tony, 16
Gill Sans, 25, 32, 32, 57
Gill Sans Bold Condensed, 33
Gill Sans Extra Bold, 50
Girvin, Tim, 17
Girvin (Tim) Design, 17, 80, 120
Glazer & Kalayjian, 55, 122
Gotschall, Edward, 13
Goudy Old Style Roman, 50
Graphic Technology, 27
graphics modifier, 21
grids, working from, 131-2
Grime, Steve, 18
Grundy & Northedge, 19, 35, 45, 63, 73
95, 121
Guinness, 96
H
Haas Helvetica, 36
Harris, David, 16, 16
headline machines, 20
headlines, 31, 38-9
in advertising, 32
mixing faces, 66-7
style and market target, 68

```
healthy colours, 87-8
Helios, 36
Helvetica, 11, 16, 16, 28, 32, 36, 118
highway signs, 118
Hill, Brian, 133
Hobbs, Stencil, 96
household products, 100-1
Hyde, Anthony, 23
hyphenization, 46
i-D, 68
illumination, 15
information communication, 116-19
International Typeface Corporation
  (ITC), 13, 13
Isabell Bold, 25
Isabell Bold Italic, 25
Isabell Heavy, 25
Isabell Heavy Italic, 25
Isabell Medium, 25
italic, 11
  use as emphasis, 52
ITC Berkeley Old Style, 51
ITC Century, 13, 13
ITC Galliard, 44
ITC New Baskerville, 45-6
ITC Novarese Bold Italic, 51
ITC Serif Gothic, 13, 13
Jacksons of Piccadilly, 99
Jones, Bill, 100
Jonson Pederson Hinrichs and Shakery,
Jordans, 87
Kalayjian, Vásken, 55
Kelsey, David, 47
Kennedy, Roger, 37
kerning, 45
key size, 10, 11
Labour Party, 89
Larson, Gun, 125
legibility:
  colour and, 60-3
  colour blindness and, 70-3
  letter spacing, 39-43
  line spacing, 48-9
  reversed-out white, 56-9, 60
  suitable faces, 30
 tonal colour and, 38-55
 type on texture, 64-5
  word spacing, 44-7
Letraset, 16, 16, 120, 121
letter spacing, 39-43
Leung, Nancy, 52
line feed, 48
line spacing, 48-9
Lloyd Northover, 59, 82, 84, 90, 100, 113,
logotype design, 16-18, 17-18
```

City Limits, 109

Clarendon, 25

Lohkamp, Magnus, 72	posters:	set-size, 40	mixing, 32-6, 66-7
Lowe Howard-Spink Campbell-Ewald	mixing typefaces, 34	shape, typography as, 12-23	modifying, 20-2
Agency, 133	reversing out, 61	shapes, counter, 16	product suitability, 28
lower case, 15	products, typeface suitability, 28	shop signs, 117	for running text, 30
Lubalin, Herb, 23, 23	promotion, market targets, 68, 96-7	signs:	tonal colour and, 38-55
Lucas Industries, 122, 119	publications, colour in, 108-9	road, 28	variations, 36-7
M	Q	shop, 117	U
magazines, 108-9	QDOS, 121	warning, 28, 79	U & l.c., 38
maps, 117	Quarto, 121	Skald, 65, 108	Uncial, 14
market targets:	Quay, Tony, 16	small caps, 52-3	Unica, 26
colour and, 96-7	quiet colours, 78	sophisticated colours, 94-5	unit system, 40, 44
style and, 68	R	Souvenir, 56, 58	Univers, 10, 21, 25
masculine colours, 93-4	readability:	Souvenir Demi Italic, 38-9	
Max and Hunter Brown, 33	colour and, 60-3		Univers 45 Light, 51
	colour blindness and, 70-3	Souvenir Gothic, 25	Univers Medium Condensed, 41
measuring type, 11		Souvenir Light Italic, 38-9	upper case, 15
Medici Script, 25	letter spacing, 39–43	spacing:	emphasis with, 52
Medieval Italic, 50	line spacing, 48-9	letter, 39–44	Usherwood Black Italic, 25
Megaron, 36	reversed-out white, 56-9, 60	line, 48-9	V V
Mellor, Richard, 113	suitable faces, 30	word, 44–7	Varityper, 36
menus, 33, 36	tonal colour and, 38-55	Square Serif, 25, 25, 26, 26	Vaughn Wedeen Creative Inc., 36, 69, 10
Miller, Blake, 69	type of texture, 64–5	street signs, 118	124
Minale, Tattersfield & Partners, 17, 29, 80,	word spacing, 44-7	Stylistic/Novelty, 24, 26, 26	Vegas, 16
81, 83, 85, 87, 88, 93, 94, 95, 98, 101	reader reply coupons, 33	symbolism, in colour, 81	Veljovic Black Italic, 25
Modern Serif, 24, 24, 26, 26	reversed-out type, 56-9, 60-1	Ť	Veljovic Bold, 25
Modified Sans Serif, 25, 27, 27	RIBA, 88	Tandem Studios, 35	vibrant colours, 88-9
Mohawk Paper Mills, 65	rivers, 46	Tayburn, 72	Vienna Secession, 95
Mulligan, Gerry, 18	road signs, 118	TBWA, 86	vision, colour deficiency, 70-3
Musisca, 16, 16	Robins, Seymour, 65	technology, 112-13	W
N	Robinson, Bennett, 49	textures, 18	Wakeman, Robert, 27, 44, 46, 49, 51, 54
NBC, 106	Rockefeller Center, New York, 79	type on, 64-5	Walbaum Italic, 32
Neue Lutherische Fraktur, 26	Rockwell, 25, 26, 28	Thompson, J. Walter, 89, 96	Waldie, Alan, 133
New Gothic, 36	Rockwell Bold, 28	Tiffany, 24	warm colours, 80-1
Newtext Regular, 25	Rockwell Regular, 57	Times, 32	warning colours, 79
non-connecting scripts, 25, 27	Rockwell Roman, 51	Times Modern Outline, 27	warning signs, 28, 79
Novarese Bold, 25	roman letters, 11	timetables, 117	Wedeen, Steven, 36
Novarese Bold Italic, 25	Romans, 14, 14	toiletries, 100-1	white reversed out of black, 56-9, 60
0	rub-down lettering, 16, 16	tonal colour:	Wong, Allen, 67
Old Style Serif, 18, 24, 24, 26, 26	Ruesch, Daniel, 35	letter spacing, 39-44	wooden display type, 18, 18
Optima, 25, 27	run-arounds, 126, 129-31	line spacing, 48-9	word spacing, 44-7
Outline, 10	running text, 30	typefaces and, 38-55	wordsets, 16
Outline/Inline, 27, 27	S	variation and emphasis, 52-5	World, 55
p	Saatchi & Saatchi, 37	word size and, 44-7	Worthington Design, 59, 85, 92, 93, 113,
packaging, feminine colours, 82	Sample, Paul, 18	transfer lettering, 16, 16	124
Pantone, 121	sans-serif typefaces, 11, 24, 25, 26, 26	travel, 104-5	X
Parliament Roman, 48		Travis, Dale & Partners, 91	x-height, 10, <i>11</i>
	Scangraphic, 36	Trickett & Webb, 28, 30, 31, 88, 93, 101,	Y
The Partners, 19, 31, 35	Scripts, 24, 25, 27, 27	125, 130	_
pastel colours, 82	SDP/Liberal Alliance, 89	AND THE RESERVE OF THE PROPERTY OF THE PROPERT	Yellowhammer, 34
Pemberton, Jeremy, 34	semi-justification, 46-7	Triumvirate, 36	Z .
Pentagram (UK), 30, 37, 55, 61, 65, 81, 83,	Senator Display, 16	Tse, Jonas, 52	Zapf Chancery, 25, 27
100, 102, 112, 115	serif, 11	type families, 10, 26-7	Zapf Chancery Bold, 25
Perpetua, 17	Serif Gothic, 13, 13	type size, 10, 11	Zographos, Paula, 49
pica em, 40	Serif Gothic Heavy, 38-9	typefaces:	
Plantin, 24	serif typefaces, 11	categories, 24-6	
point size, 10, 11	Serifa, 69	creative, 18-20	

Acknowledgements

p12-13: Bob Farber; p14: top, Ursula Dawson, London; bottom right, Victoria & Albert Museum, London; p15: top, Peter Thompson; bottom, Georgia Deaver, San Francisco, California; p16: top left, David Harris; top right, Tony Geddes; centre, David Quay; p17: top left and bottom, Tim Girvin Design, Inc., Seattle, Washington; top right and top, Minale, Tattersfield & Partners Ltd, London; centre above, W Photo, London; centre below, Vaughn/Wedeen Creative, Inc, Albuquerque, New Mexico; p18: top right, DRG Records: Art Director John de Vries; bottom left, Foote, Cone & Belding, London: Designer Steve Grime: Illustrator Paul Sample; bottom right, Paul Peter Piech (detail); p19: top, Michael Beaumont; centre left, Grundy & Northedge, London; centre right, The Partners Ltd, London: Art Director Aziz Cami: Designer Stephen Gibbons: Illustrators Stephen Dew, Line &

Line: below. The Yellow Pencil Company Ltd, London; p22: Conway Group Graphics Ltd, London; p23: Herb Lubalin; p25: Robert Wakeman, N W Aver Inc., New York; p27: Robert Wakeman, N W Ayer Inc., New York; p28: top left, top right, centre left, Minale Tattersfield & Partners, Ltd. London; centre, Coley Porter & Bell & Partners, London; bottom left, Trickett & Webb Ltd, London; p29: Minale, Tattersfield & Partners, London; p30: top, Pentagram UK, London; bottom, Trickett & Webb Ltd, London; p31: top left, top centre, top right, Trickett & Webb Ltd, London; bottom right, The Partners Ltd, London: Art Director Nick Wurr. Designer Clare Boam: Illustrator Nick Brownfield; bottom left, The Partners Ltd, London: Art Director Aziz Cami: Designer Karen Wilks; p32: The Artist's and Illustrator's Magazine, London; p33: left, Lloyd Northover Ltd, London; right, Case Associates, Toronto, Canada: Designer Mark Walton: Artist Julius Ciss: Writer Pamela Frostad; p34: Lynx, Dunmow, Essex, England; Photography David Bailey; p35: left, Appleton Design, Hartford, Connecticut: Art Director/Designer/Typographer Robert Appleton; centre top and top right, Grundy & Northedge, London; centre bottom, Tandem Studios, Salt Lake City, Utah: Designer Daniel Reusch; p36: Vaughn/Wedeen Creative, Inc., Albuquerque, New Mexico: Art Director/Designer/Illustrator Steven Wedeen: Copywriter Susan Blumenthal; p37: top, Pentagram UK, London; bottom, Saatchi & Saatchi Compton Ltd, London: Art Director Paul Arden: Photographer Richard Avedon: Copywriter Tim Mellors: Typographer Roger Kennedy; p38: U.&l.c., New York: Illustrator Gina Shartleff: Writer Marion Muller; p44: Robert Wakeman, N W Ayer Inc., New York; p45: Grundy & Northedge, London; p47: left, Redmond Fugate Amundson Rice & Ross, Richmond, Virginia; right, Robert Wakeman, N W Ayer Inc., New York; p49: top left, Robert Wakeman, N W Ayer Inc., New York; bottom, Corporate Graphics, New York: Typography/Design Bennett Robinson, Paul Zographos; p51: Robert Wakeman, N W Ayer, Inc., New York; p.52: Olympia & York Developments, Toronto, Canada: Art Director Simha Fordsham: Designers Nancy Leung, Jonas Tse; p.53: top, The World of Interiors Magazine, London; bottom, The Yellow Pencil Company Ltd, London; p54: Robert Wakeman, N W Ayer Inc., New York; p55: top left, Glazer & Kalayjian Inc., New York: Typography/Design: Vasken Kalayjian; top right and bottom, Pentagram UK, London; p59: left, Lloyd Northover, London; right, Richard Mellor, London; p61: left, Chermayeff & Geismar Associates, Inc., New York: Art direction, Design and Illustration Steff Geissbuhler; bottom right, Pentagram UK, London; p62: Vaughn/Wedeen Creative Inc., Albuquerque, New Mexico; p63: top left and bottom right, Vaughn/Wedeen Creative, Inc., Albuquerque, New Mexico; top right, Grundy & Northedge, London; bottom left, Cope Woollcombe & Partners, London; p64: Vaughn/Wedeen Creative, Inc., Albuquerque, New Mexico; p65: top, Seymour Robins Design, Sheffield, Mass; bottom left, Pentagram UK, London; centre top and bottom right, Artist's and Illustrator's Magazine, London; p67: top, Brown Design Group, Providence, Rhode Island: Designer/Typographer Allen Wong; bottom, Crucial Books, London; p68: i-D magazine, London; p69: top, Miller Judson & Ford, Inc., Houston, Texas: Art Director/Designer Blake Miller: Photographer Wayne Jesperson; bottom left and bottom right, Vaughn/Wedeen Creative, Inc., Albuquerque, New Mexico; p71: Canon (UK) Ltd, Wallington, Surrey, England; p72: The Post Office, Great Britain; p73: Grundy & Northedge, London; p76: J. Walter Thompson Co. Ltd, London: Photographer Max Forsythe: Art Director/Designer Luciana Carta: Copywriter Geoff Weedon: Typographer Trevor Slabber; p77: top right, Pentagram UK, London; centre, David Davies Associates, London; bottom left, Minale Tattersfield & Partners Ltd. London; bottom right, Trickett & Webb Ltd, London; p80; top and bottom, Tim Girvin Design, Inc., Seattle, Washington; centre, Minale, Tattersfield & Partners Ltd, London; bottom, David Davies Associates, London; p82: top and centre right, Coley Porter Bell & Partners, London; centre left, David Davies Associates, London; bottom, Lloyd Northover Ltd, London; p83: top left, Minale, Tattersfield & Partners Ltd, London; top right, Pentagram UK, London; bottom left, Quarto Publishing Plc, London; bottom right, Vaughn/Wedeen Creative Inc., Albuquerque, New Mexico; p84: top right, Lloyd Northover Ltd, London; bottom left, The Partners, Ltd, London: Art Director David Stuart: Designers Shaun Dew, Clare Boam; bottom centre, M & R Martini Rossi Ltd, UK; p84-85: bottom left, Fitch & Company Plc, London; p85: top left, Minale, Tattersfield & Partners Ltd, London; top right and bottom right, Richard Mellor, London; p86: top, T.B.W.A. Ltd, London: Creative Team John Knight; bottom, Vaughn/Wedeen Creative Inc., Albuquerque, New Mexico; top right, J. Walter Thompson Co. Ltd, London: Art Director Annie Carlton: Photographer David Fairman: Posterization Gilchrist Studios; centre right, Social Democratic Party, UK; bottom left, Minale, Tattersfield & Partners Ltd, London; bottom right, The Labour Party, UK: Designer Mike Jarvis; p90: top, Travis Dale & Partners, London; bottom left, Fitch & Company, London; bottom right, Lloyd Northover Ltd, London; p91: top right, Quintet Publishing Plc, London; bottom left, Pentagram UK, London; bottom right, Minale, Tattersfield & Partners Ltd, London; p92: top left, top centre and centre, David Davies Associates, London; top right, Minale, Tattersfield & Partners Ltd, London; bottom, The Worthington Design Co, London; p93: top, Richard Mellor, London; centre, Vaughn/Wedeen Creative Inc., Albuquerque, New Mexico; bottom left, Trickett & Webb Ltd; bottom right, Minale, Tattersfield & Partners Ltd, London; p94: top left, Minale, Tattersfield & Partners, Ltd, London; top right, Quarto Publishing Plc, London; centre left, Fitch & Company Plc, London; centre, Vaughn/Wedeen Creative Inc., Albuquerque, New Mexico; p95: top left, Cope Woollcombe & Partners, London; top centre, Coley Porter Bell & Partners, London; top right and centre, Minale, Tattersfield & Partners Ltd, London; bottom left, Grundy & Northedge, London; p96: top centre and bottom, Coley Porter Bell & Partners, London; right, Fitch & Company Plc, London; p97: top, Fitch & Company Plc, London; bottom right, Georgia Deaver, San Francisco, California; bottom left and bottom centre, Minale, Tattersfield & Partners Ltd, London; p98: top, The Ian Logan Design Company, London: Designer/Typographer Alan Coleville: Illustrator Brian Cook; bottom left, John Brimacombe & Co., London; bottom right, Minale, Tattersfield & Partners Ltd, London; p99: top left, top centre, centre, right, and bottom right, Coley Porter Bell & Partners, London; bottom left, Saatchi & Saatchi Compton Ltd, London: Typographer David Wakefield: Art Director Stewart Howard: Copywriters Rod Lyons/David Bourne; p100: top left, Fisher, Ling & Bennion Ltd, Cheltenham: Designer Bill Jones; right, Pentagram UK, London; bottom, Lloyd Northover Ltd, London; p101: top and bottom, Trickett & Webb Ltd, London; centre left, Lloyd Northover Ltd, London; centre right, Minale, Tattersfield & Partners Ltd, London; p102: Pentagram UK, London; p103: top left and centre right, Fitch & Company Plc, London; centre left, Grundy & Northedge, London; bottom, Bartle Bogle Hegarty, London; p104: Lloyd Northover Ltd, London; p105: top left, Expression Design, London; top right, Field Wylie & Co, Ltd, London: Photography Andy Willis; centre, Thumb Design Partnership, London: Designer/Typographer Nick Pollitt, bottom left, Saatchi & Saatchi Compton Ltd, London: Art Directors Derek Miller, Noel Farrey: Designer Roger Pearce: Copywriters James Lowther, Richard Myers & Roger Pearce; p106: top, Glazer & Kalayjian Inc., New York; centre left, Kruddart/Muscle Films, London: Design Nicola Bruce, Michael Coulson; centre right, Kunst Co, London: Designer Martin Hucksford; bottom, Minale, Tattersfield & Partners ltd, London; p107: top left, Grundy & Northedge, London; top right, Hyper Kinetics Ltd London; centre, Deutsche Grammophon production: Design Gerhard Noack; centre right and bottom, Vaughn/Wedeen Creative, Inc., Albuquerque, New Mexico; p108: top, Pentagram UK, London; bottom, Elle magazine, London; p109: top left and top right, Quarto Publishing Plc, London; centre left and bottom, City Limits, London; centre right, Roman Meal Company, Tacoma, Washington; p 110: top left, top right, bottom right, David Davies Associates, London; bottom left, Fitch & Company, London; p111: top left, Allied International Designers Ltd, London; bottom left, David Davies Associates, London; p112: top, Cope Woollcombe & Partners, London; centre left, bottom left, bottom right, Pentagram UK, London; p113: top left, Lloyd Northover Ltd, London; right, Sutherland Hawes Design, London: Designer Richard Mellor; bottom, Pentagram UK, London; p114: top left, top centre, centre left, Banks & Miles, London; bottom, Cope Woollcombe & Partners, London; p115: top, Pentagram UK, London; centre and bottom, Allied International Designers Ltd, London; p116: bottom left, Elle magazine, London; bottom right, "Skald" magazine, Pentagram; p117: top, Trickett & Webb Ltd, London; bottom right, The French railway, SNCF; p118: top right, Michael Beaumont; centre left and bottom, Minale, Tattersfield & Partners Ltd, London; p119: top left and centre, Centre Georges Pompidou, Paris; top right, British Rail/InterCity; bottom, Pentagram UK, London; p120: right, Lloyd Northover Ltd, London; left, Tim Girvin Design Inc., Seattle, Washington; p121: top, Lloyd Northover Ltd, London; bottom left, Grundy & Northedge, London; right, QDOS Design Ltd, London; p122: top, Georgia Deaver, San Francisco, California; bottom left, Glaser & Kalayjian Inc., New York; p123: left, Coley Porter Bell & Partners, London; bottom, 'Crafts' magazine, London; p124: top, The Worthington Design Co. London; centre, Vaughn/Wedeen Creative Inc., Albuquerque, New Mexico; bottom, David Gatti, New York; p125: top left, Alfred A Knopf: Typography/Design Gun Larson, Klagstorp, Sweden; top right, Opera Photographic Ltd, London: Designer Martin Butler; bottom, Trickett & Webb Ltd, London; p130: left, Conway Group Graphics, London: Design and lettering Ben Casey: Illustrations Will Rowlands; right, Trickett & Webb Ltd, London; p131: Jonson Pedersen Hinrichs & Shakery, San Francisco, California; p132: Elle magazine, London: Photography Gilles Bensimon; p133: top, Lowe Howard-Spink Narschalk, London: Art Director Alan Waldie: Copywriter Adrian Holmes: Illustrator Roy Knipe: Typographer Brian Hill; bottom, B.B. Needham Worldwide, New York: Designer David Garcia: Writer Mike Rogers: Photographer Jim Young. Quarto would like to thank Mick Hill and Ursula Dawson. We would also like to thank those companies who so willingly sent us transparencies and artwork, and who granted us clearance of their copyright. Every effort has been made to obtain copyright clearance for the illustrations featured in this book, and we apologize if any omissions have been made.